COLNE VALLEY & HALSTEAD RAILWAY

THROUGH TIME

Andy T. Wallis

AMBERLEY PUBLISHING

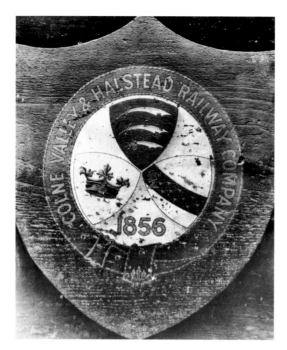

Original wooden shield of the Colne Valley &
Halstead Railway Company, 1856. (Historical
Model Railway Society/H. F. Hilton
Collection)

To all Colne Valley people – past, present, and in the future.

First published 2011

Amberley Publishing
Cirencester Road, Chalford,
Stroud, Gloucestershire, GL6 8PE

www.amberleybooks.com

Copyright © Andy T. Wallis, 2011

The right of Andy T. Wallis to be identified as the
Author of this work has been asserted in accordance
with the Copyrights, Designs and Patents Act 1988.

ISBN 978 1 4456 0351 3

British Library Cataloguing in Publication Data.
A catalogue record for this book is available from
the British Library.

Typeset in 9.5pt on 12pt Celeste.
Typesetting by Amberley Publishing.
Printed in the UK.

Introduction

The former Colne Valley & Halstead Railway was a country branch line that ran from a junction with the former Great Eastern Stour Valley branch at Chappel & Wakes Colne to Haverhill in Suffolk, where a further connection with the Stour Valley was made. Originally proposed by the good citizens of Halstead and surrounding villages of north Essex after several failed promises from the Eastern Counties Railway had come to nothing, the line was authorised by Act of Parliament on 30 June 1856 and opened with great enthusiasm on 16 April 1860 from Chappel to Halstead, a little over six miles in length. Proposals to extend the new line to Saffron Walden or Shelford were mooted, but this was later changed to Haverhill. And so a further Act of Parliament authorised the line to be extended to Haverhill. It opened in stages: Hedingham in July 1861, Yeldham in May 1862, and Haverhill CV (later South) in May 1863. An additional station at Birdbrook also opened in 1863 between Yeldham and Haverhill; the exact date is not known.

When the Great Eastern Railway finally reached Haverhill in 1865, the GER having taken over all the other lines in East Anglia in 1862, a connecting spur was built to link the two lines. From that time, most Colne Valley trains used the GE station for the convenience of interchange.

Passenger services, never very busy except on excursion or market days, survived for just over a hundred years until 1 January 1962, the final train running on the previous Saturday. Goods services continued to serve all the stations except Birdbrook, which closed completely. Over the next couple of years, these services were withdrawn. The final goods train ran in April 1965.

Demolition of the Halstead to Chappel section followed soon after the total closure of the line, the northern section having been lifted by the scrap man in 1962 and again in 1965 when the line was cut back from Yeldham to Halstead. Most of the steel bridges were also scrapped at this time, including the steel decks of bridges over public roads.

Over the years, the stations and goods yards at Birdbrook, Yeldham and Halstead were demolished for redevelopment, while the station at Earls Colne was incorporated into an industrial estate. The station at White Colne became the local village hall, the platform area having succumbed to houses.

The former Sible & Castle Hedingham station and yard was purchased by a local woodworking firm for expansion of their activities. The old station remained derelict for a number of years.

Fortunately, it was saved and taken down brick by brick in 1974 and moved to the new Colne Valley Railway, a couple of miles away from its original home. Artefacts and pieces from several other stations have been reused on the new Colne Valley Railway, including two former Great Eastern Railway signal boxes from Cressing and Wrabness in addition to an original CV&HR rail bridge, which had survived being scrapped in 1966 because the local water board required it for access to a pumping station. It was donated to the CVR in return for a replacement footbridge.

This book will show you what has happened to the rest of the line over the last forty-five years since the closure of the route, together with nearly forty years of preservation at Castle Hedingham.

ATW
February 2011

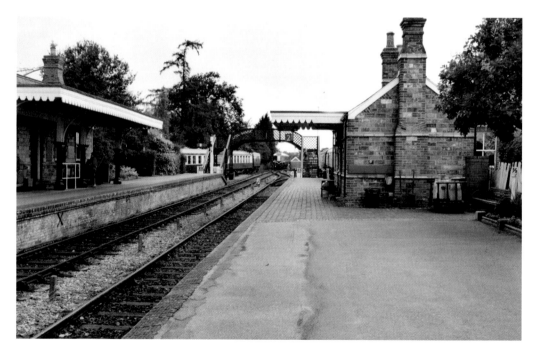

A present-day scene on the current Colne Valley Railway, showing the rebuilt Sible & Castle Hedingham station which was taken down brick by brick and moved some two miles to the new railway. The station building dates from 1861 and shared the same brickwork design as White Colne and Halstead. The building on the opposite platform was constructed from materials salvaged from several stations, including Cavendish, St Ives and Yeldham. (ATW)

Haverhill South and Colne Valley Junction

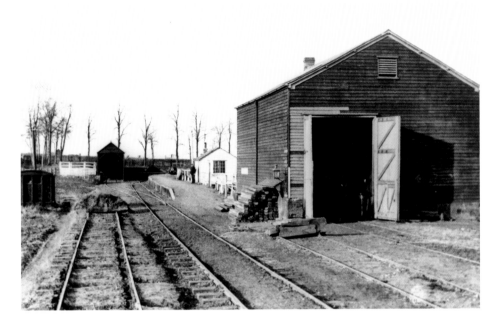

An early picture of the original Haverhill Colne Valley station when it was still open to passenger traffic. Note the simple buildings and the large goods shed on right, which features in all the later views of the station. (M. Brooks Collection) The current view is of houses and car parking space. The original terminus was adjacent to Duddery Hill Road and Colne Valley Road, opposite the goods shed that serviced the Colne Valley station. Ninety per cent of the station site has now been redeveloped with houses and industrial units. (Ray Bishop)

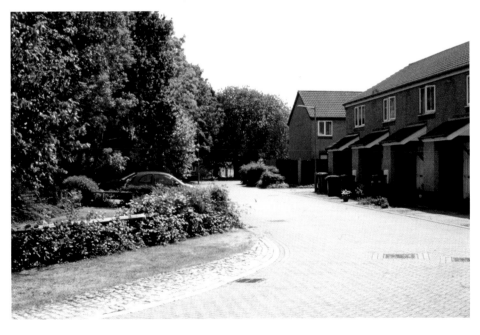

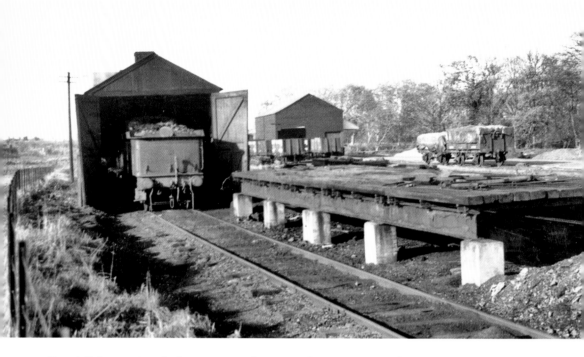

Haverhill locomotive shed, as seen in this November 1935 view. The water tower is located behind the shed and the goods shed can be seen on the right with plenty of trucks waiting to be loaded or unloaded in the yard. (Mile Post 92.5 Picture Library) The modern view in 2010 is again of houses that have completely obliterated the station site. There are no landmarks that appear in both pictures. (RB)

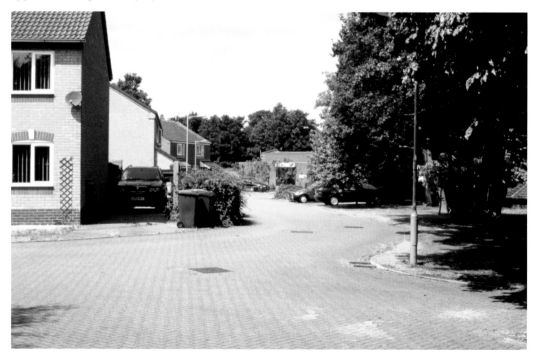

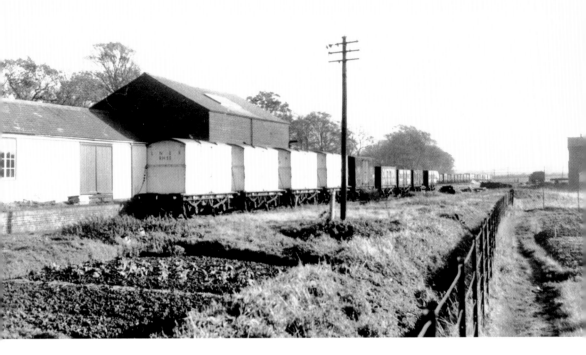

A 1935 LNER view of Haverhill station, goods shed and yard, looking south. Note how the spare ground between the sidings and boundary fence has been cultivated as allotments. (MP92.5) The view today shows part of a large housing development which, along with an industrial unit and car park, has completely taken over the station and yard site. (RB)

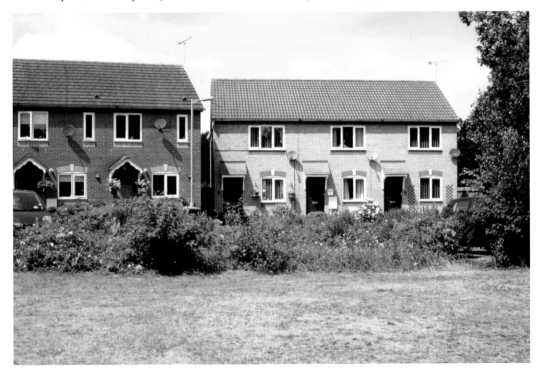

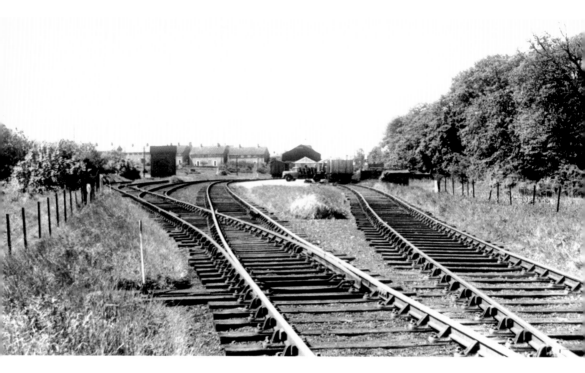

The approach to Haverhill South, with the water tower and goods shed in the distance, as viewed on 27 May 1957. (R. M. Casserley) This area today is now a mixture of houses and industrial units; the trackbed from Colne Valley Junction can be walked up to this point. (RB)

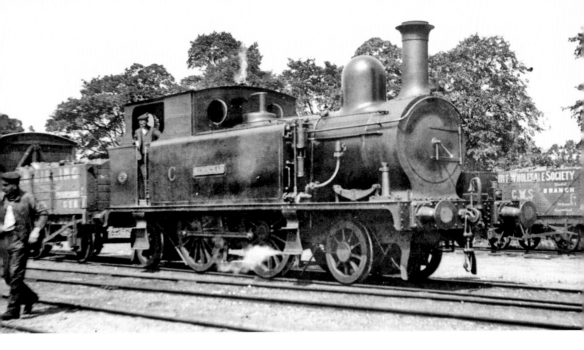

CV&HR locomotive No. 4 *Hedingham* is seen shunting at Haverhill South on 29 July 1911. (Ken Nunn Collection/LCGB) Today, however, this view is completely changed: the trackbed is now a footpath that runs from the former Colne Valley Junction towards Haverhill South. It is at this point that the whole station area has been redeveloped. (RB)

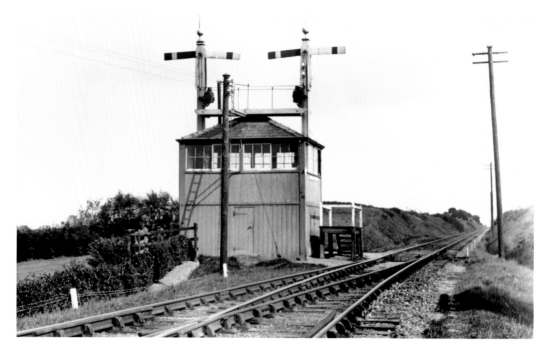

The former Colne Valley Junction signal box with the semaphore stop signals above the roof. This signal box was opened by the GER in 1865 and was manned by Colne Valley personnel. In 1911, the signals above the roof were removed and placed in a more standard position on the approaches to the junction. (CVRPS Ltd Collection) The whole area is now totally overgrown with trees, bushes and shrubs, although with care one can still follow the path of the formation for a short distance in both directions. (RB)

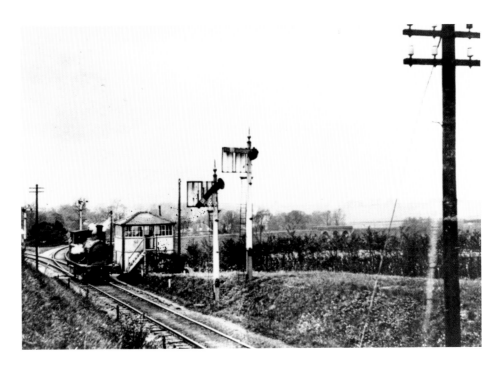

By 1912, the old signal box had been converted to comply with 'modern' standards with the stop signals erected at the approaches to the junction. In an image dating from around 1918, a light locomotive is just passing the box, heading towards Haverhill CV. (HMRS/ HFH) Today, this view is gone. The former trackbed has been designated a public footpath, although, with no sign of land management, trees and bush growth have taken control of this area. As the junction area is so overgrown, an alternative view from the top of the viaduct is provided, looking north towards Haverhill town centre. (RB)

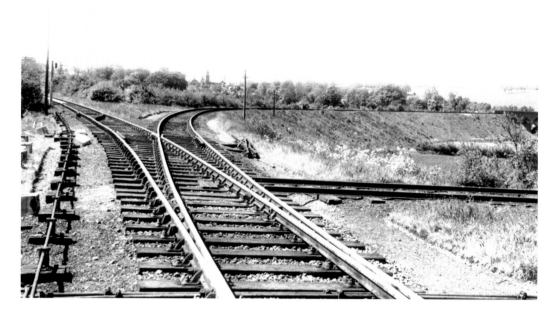

Haverhill Colne Valley Junction, viewed from the site of the former signal box, on 27 May 1957. On the extreme right of this view can be seen 'Sturmer Arches', also known as Hamlet Road viaduct, which is now a listed structure and still stands guarding the entrance to Haverhill. No trains have passed over it since 1965. (RMC) In 1979, the author was able to find in the nearby bushes the old concrete stools that used to carry the rodding for working the points. Today, the view has greatly changed, but it is still possible to walk with care round to the old viaduct. (ATW)

Birdbrook

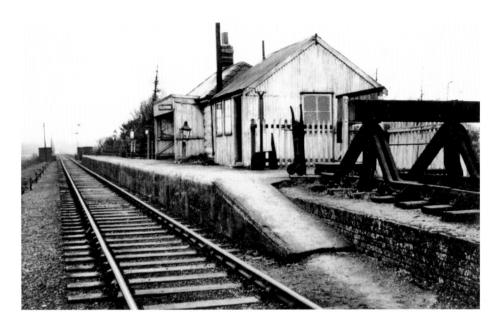

Birdbrook station, as viewed in 1961, looking north with the original building and the newer structure erected in 1907. In the distance can be seen the up home and down starting signals that shared the same post. By this time they had been converted to upper quadrant signals. (CVRPS) Not long after this photograph was taken the trains and track were gone, together with the newer building. The bottom picture was taken in November 1965, Birdbrook station having closed completely for all traffic on 1 January 1962. The last trains ran on the previous Saturday. There was no Sunday service. (M. R. Davies)

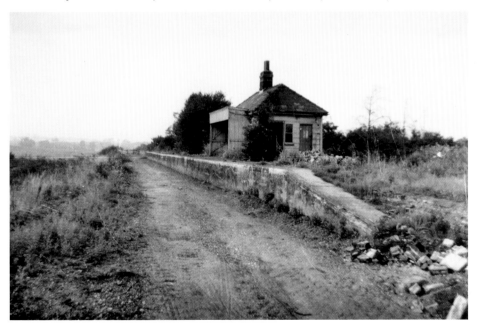

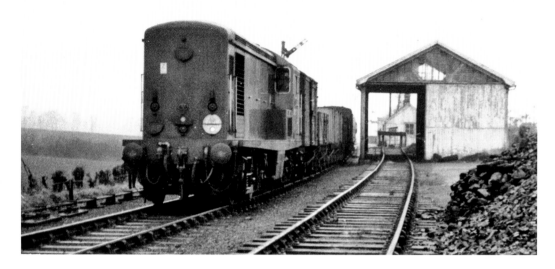

D8200 type 1 diesel arrives at Birdbrook on Saturday 30 December 1961 to clear the yard of any remaining wagons on the last day of service. The station buildings can be seen through the goods shed. (Vincent Heckford/CVRPS) The goods shed on the right still stands today and is used to store agriculture vehicles. Grain silos have been sited on other parts of the yard. A telecoms tower has been erected behind the goods shed on what would have been the end of the platform. (RB)

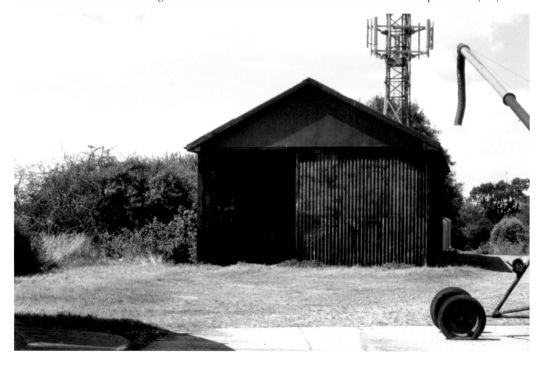

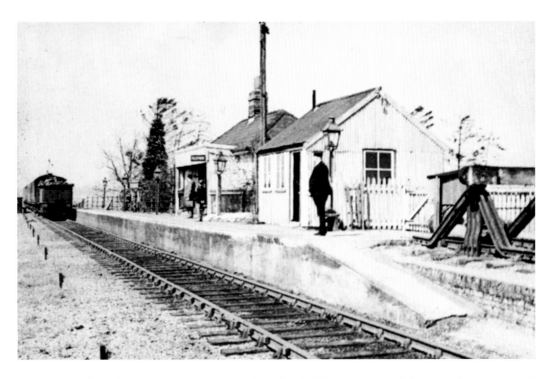

A view from the 1947 line survey carried out by the LNER. Note the full range of buildings and the signalman waiting to exchange the token for the section of single line to Yeldham. (BR/CVRPS) A modern-day view shows that extensive foliage has completely taken over the former trackbed between the edge of the embankment and the platform. (RB)

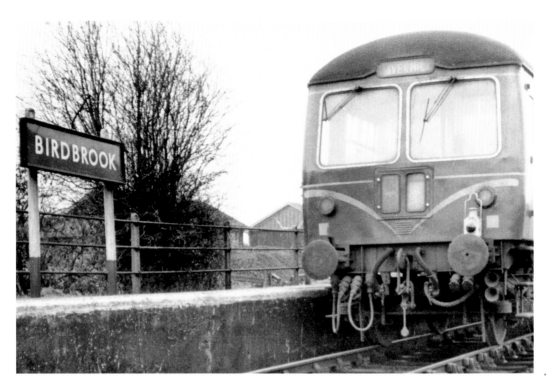

Close-up of a DMU at Birdbrook in 1961. The buildings in the background comprise the goods shed, while the yard is out of sight to the right. (Vincent Heckford/CVRPS) Today, the coal ground has survived because of the concrete base, and the brickwork of the loading dock can still be made out. The gap between the two lots of trees on the right is the trackbed leading to Birdbrook cutting. Several large grain silos have been built on the goods yard site. (RB)

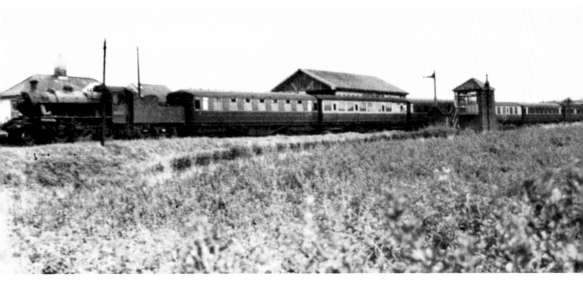

An Ivatt-designed 2MT No. 46465 hauls a returning Clacton excursion, consisting of eight coaches, through Birdbrook, en route to Cambridge during the summer of 1961. Note the signal box, goods shed and station buildings, and the lack of tree growth at this time. (P. Waylett/ CVRPS) Today, the same view reveals the growth of trees and shrubs. Hidden among them are the old goods shed and platform, while a large telecoms tower dominates the whole area. The former signal box would have been where the grain silos are now sited. (RB)

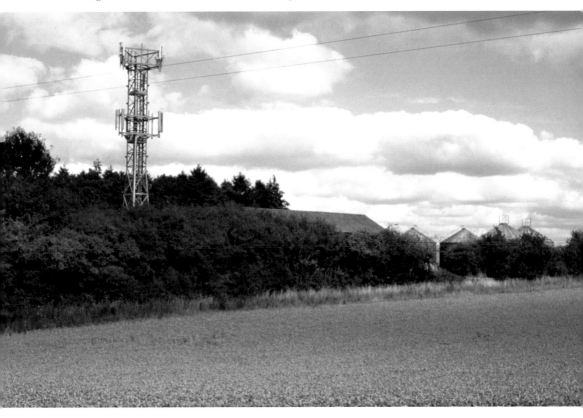

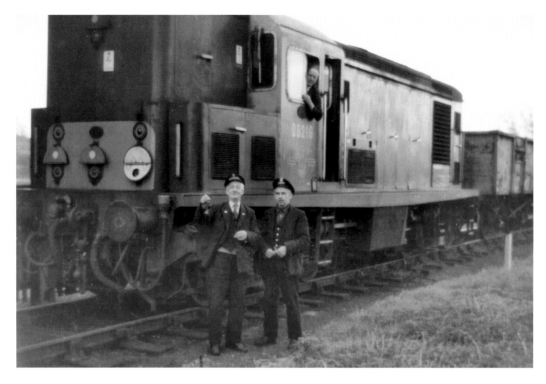

The crew of the morning goods train pose for the camera while shunting the yard at Birdbrook. The locomotive is a Class 15 diesel, No. D8216. (Ron Hutley) In the modern view we see the end of the goods shed now used to store combine harvesters. The area in the foreground was where the earlier photograph was taken but it is now completely overgrown with trees and shrubs. (RB)

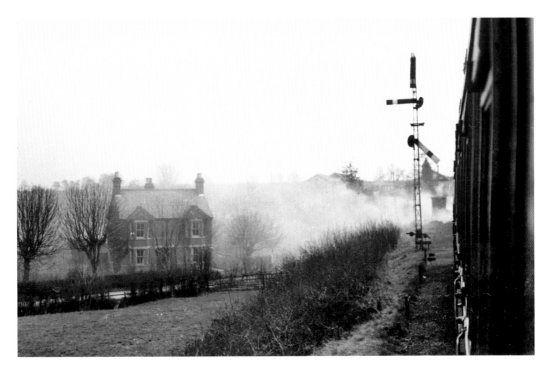

A view looking back at Birdbrook station and signals from a down-direction passenger service on 6 April 1955. The two cottages in this view are the common feature in both pictures. The signals had just been converted to having the spectacles joined to the arms. Later still, both arms were converted to upper quadrants not long before the line closed. (RMC) Today, the trackbed is used by the local farmers as an access track, apart from a portion next to the bridge that has been left to nature, thus making it impossible to exactly recreate the original view. However, by going down to road level, a good view of the former station cottages, now much improved, can be obtained. (RB)

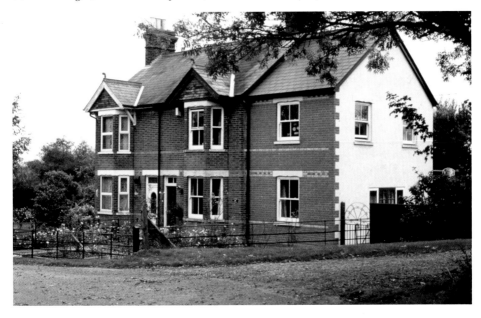

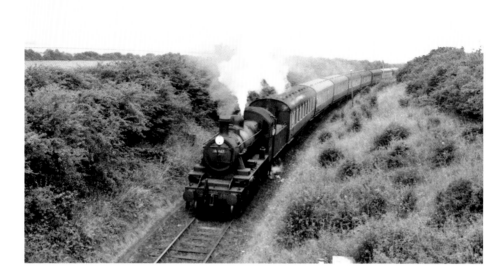

Class 2MT locomotive 46467 on a Clacton to Cambridge excursion service entering Birdbrook cutting in the late 1950s. These special summer excursion trains usually consisted of eight coaches and had to pull up twice at Colne Valley stations due to the short platforms. (Dr I. C. Allen/Transport Treasury) By 1963 the scrap man had removed all the rails and sleepers and had even taken the ballast to leave just an empty trackbed. The photograph below was taken in 1963. The bridge was a favourite haunt of photographers, as were the embankments on either side. The cutting is now completely overgrown and impassable. (RH)

Yeldham

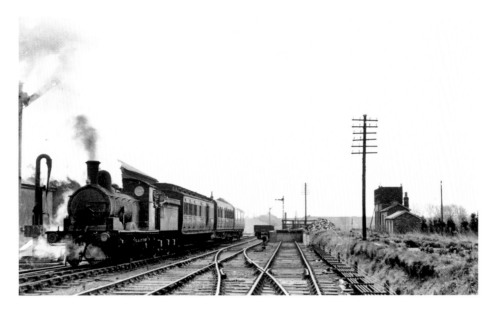

In April 1949, a J15 with three coaches makes a fine start away from Yeldham en route to Haverhill and Cambridge. On the right can be seen the loading dock, water tower and pumping room. (M. Whitehouse Collection) This site is now owned and managed by Essex County Council, who in 2010 spent some time creating a new footpath from the station road to a point several hundred yards away to join the existing footpath network. Clearance of some of the trees and bushes has opened up the view of the old platform. (Paul Lemon)

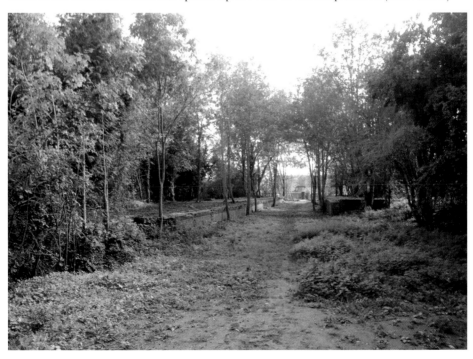

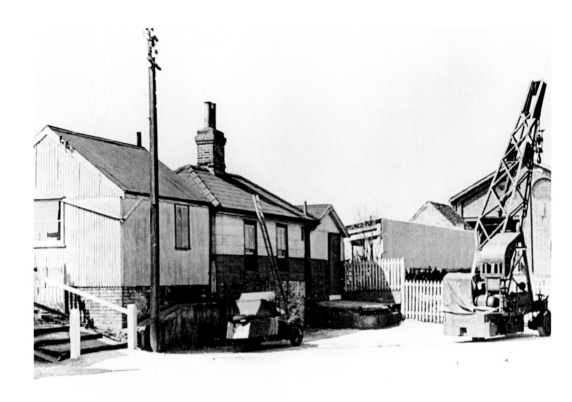

A 1947 view of the exterior of Yeldham station, showing the newer building and original building. The goods shed is in the background with a mobile crane in the yard in front of the station. (BR/CVRPS) The modern view – taken from the same location, although much improved of late – shows a bank of dirt and much tree growth. Behind the bank and trees are the remains of the platform. The roadway leads to the council depot. (RB)

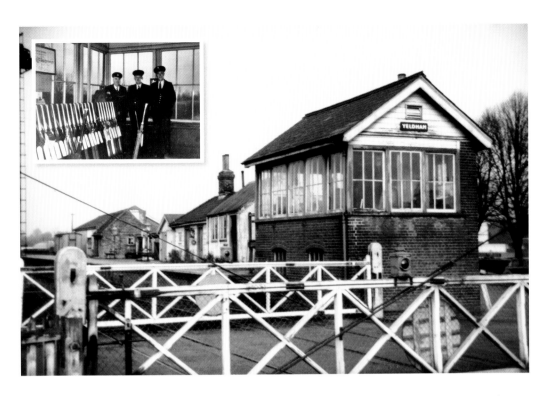

A view of Yeldham signal box taken from the level crossing. The inset shows the stationmaster, porter and signalman standing at the end of the 26-lever Saxby & Farmer lever frame. (RH) In 1962, the wooden top of the signal box was demolished, leaving the brick base standing for a number of years. The level crossing gates survived well into the 1980s before finally being removed and replaced with a chain-link fence. Today, nothing of the old signal box exists except for a hole in the ground hard up against the road. Now that some of the vegetation has been cleared, the old platform is more visible. (RB)

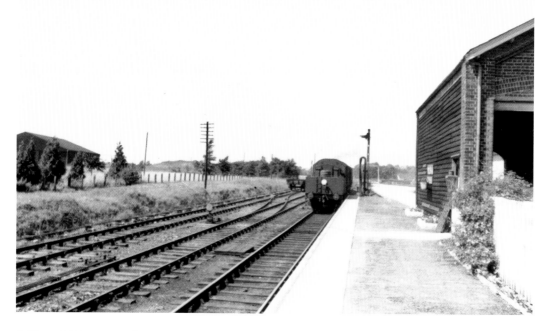

A Class 2MT Ivatt-type locomotive approaches Yeldham platform from the north with the goods shed on the right and the down starting signal in the distance. The goods shed was knocked down before the station closed completely in December 1964. (Stations UK) Today, one can stand on the remains of the platform and look in the same direction, but only to see the security fence of the council's highways depot. A public footpath now runs to the left of the depot. (PL)

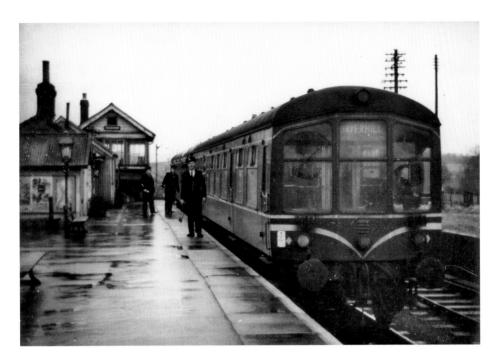

A two-car diesel unit pauses briefly at Yeldham on a wet day in December 1961. Normally the Colne Valley passenger service was in the hands of the diesel rail buses; these were diagrammed on lightly used rural lines in and around Cambridge. (RH) The view today again reveals nature taking over. A pathway has recently been created on the trackbed between the old platform and loading dock. (RB)

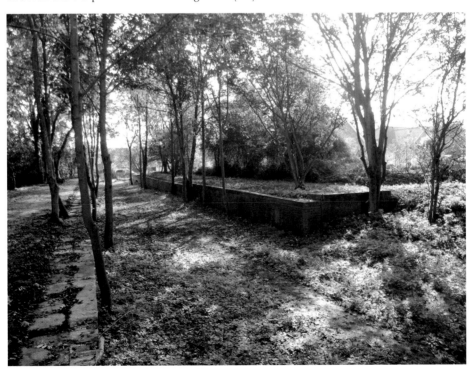

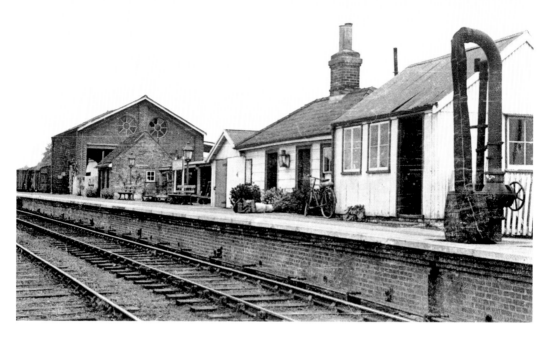

A general view of Yeldham station in 1952, showing all the buildings and the station sign, under which was a raised concrete step that had a barrel sitting on it. (SUK) Today, the sign and barrel have long gone, but the raised concrete step has re-emerged from under the trees and shrubs that have hidden it for many a year. (PL)

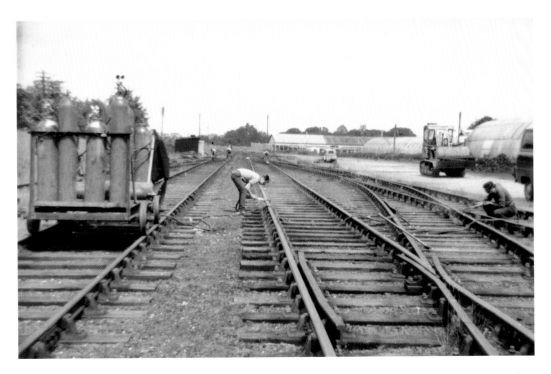

The scrap man cometh: demolition of the track taking place in Yeldham yard. The cutters reduced the rails and crossings into manageable pieces for loading on to the scrap train. The station closed to goods traffic in December 1964. (RH) Today, this view is of the council's highways depot with a large supply of stone chippings for road maintenance surrounded by a security fence. (PL)

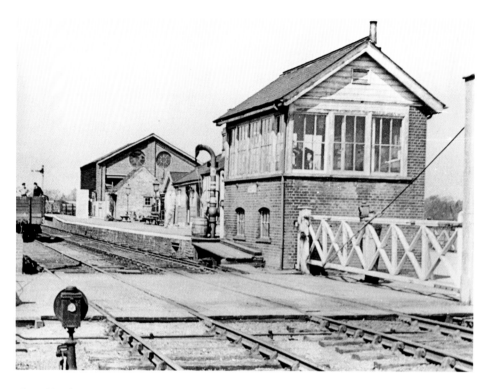

The official 1947 view of Yeldham station, signal box, goods shed and level crossing. The up starting signal is on the left and was renewed by the LNER in concrete. The shunt signal in the foreground was an original rotating Dodd and has since been preserved at the new Colne Valley Railway. (BR/CVRPS) The view today, although much improved with the opening of the new footpath, still only shows the platforms and trackbed. There is a definite hump in the road where the level crossing was. Rumour has it the rails are still in situ, buried beneath the tarmac. (RB)

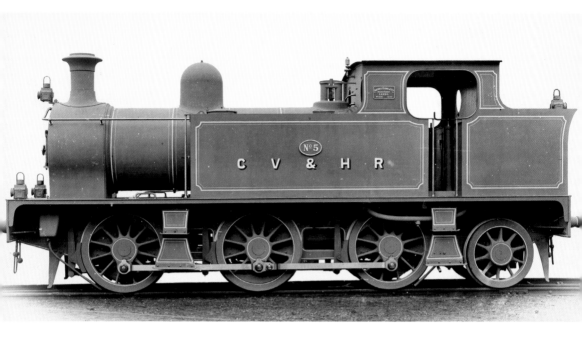

Official photograph of CV&HR locomotive No. 5, as built by Hudswell Clarke & Company Ltd. Works No. 836 of 1908. This locomotive survived into LNER ownership and spent its later life shunting at Colchester and working on the Brightlingsea branch line. (CVRPS) The image below shows J15 locomotive No. 65462 on a visit to the Colne Valley Railway from the North Norfolk Railway as it enters Castle Hedingham station with a special goods train in 2004. (RB)

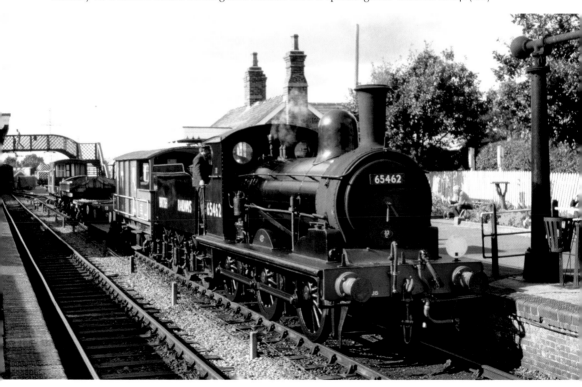

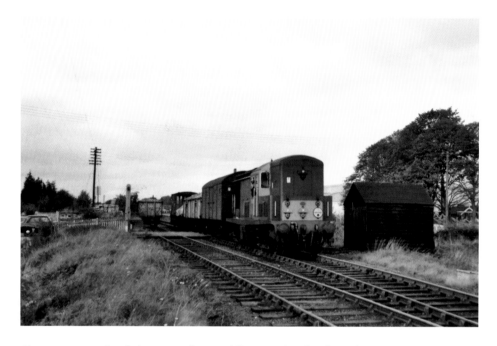

Class 15 type 1 diesel departing from Yeldham with a local goods train, working in the period after the passenger service was withdrawn. (Dr I. C. Allen/Class 15 Preservation Society Collection) The view today is from slightly further away from the level crossing as two bungalows have been built on the trackbed. The view looking towards the station is obscured by trees and shrubs. If these were cut down, one would see the back gardens of the new bungalows. (PL)

Sible & Castle Hedingham

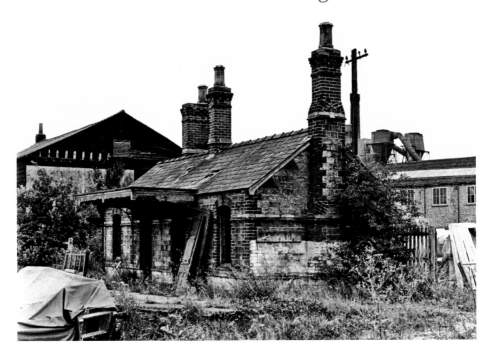

A very derelict Sible & Castle Hedingham station and goods shed awaiting its fate in the early 1970s. Fortunately, the then owners, when approached by the infant Preservation Society, readily agreed to give the building to the new Colne Valley Railway. It was duly dismantled brick by brick and moved to its new home. (Adrian Corder-Birch Collection) The present-day view shows the station rebuilt on the new Colne Valley Railway. The structure still features the white stock bricks that also feature in the Halstead and White Colne station buildings. (RB)

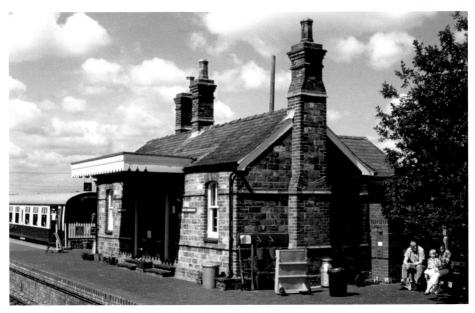

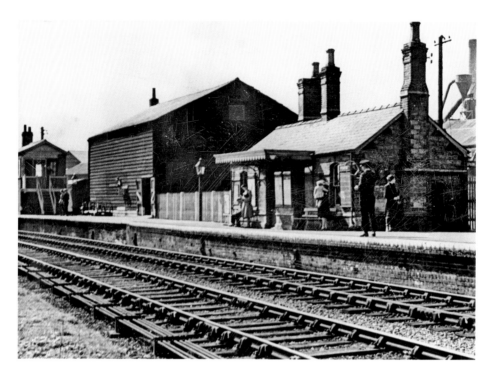

Sible & Castle Hedingham in 1947 with an up-direction train approaching the platform (out of shot). The signalman is waiting to exchange tokens, and there appear to be seven potential customers, which isn't bad for a Colne Valley station. (BR/CVRPS) The photo below, taken in early 1974, shows the cleared site awaiting the expansion of the nearby woodworking business. The buildings on the left feature in both photographs, but the site has since been completely built over. (CVRPS)

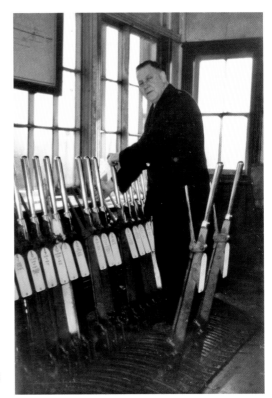

Porter signalman Charlie Bacon in Sible & Castle Hedingham signal box in 1961, working the Saxby & Farmer 25-lever frame. (RH) This picture could not be recreated now so instead the photograph below shows John Lowing working the Saxby & Farmer 25-lever frame at Nunnery Junction (formerly Wrabness) on the rebuilt Colne Valley Railway in 1994. (ATW)

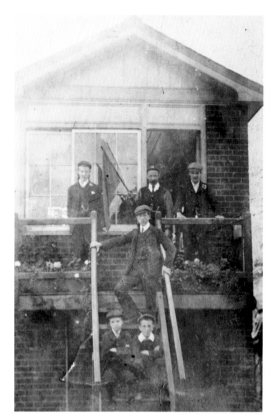

Station staff pose for a photograph on the steps and balcony of Sible & Castle Hedingham signal box. The date of the picture is not known, but it is believed to be from the early twentieth century. (ACB) The modern photograph was created using the present Castle Hedingham signal box with staff standing on the balcony in period costume during a Victorian education event in 2010. (PL)

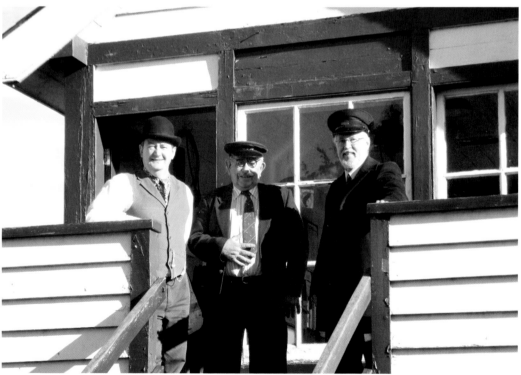

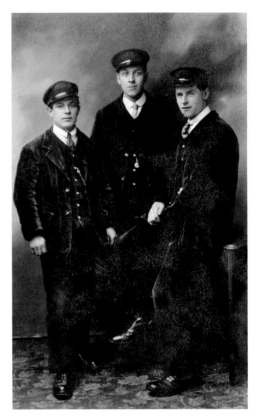

Three fully uniformed CV&HR station staff pose for a photograph, *c.* 1918, at Sible & Castle Hedingham station. (CVRPS) By way of a contrast, the more recent photograph shows three of the CVR's Permanent Way staff working in the cutting at Nunnery Junction. They were creating a small display of painted white stones that spell out the word 'Nunnery'. (ATW)

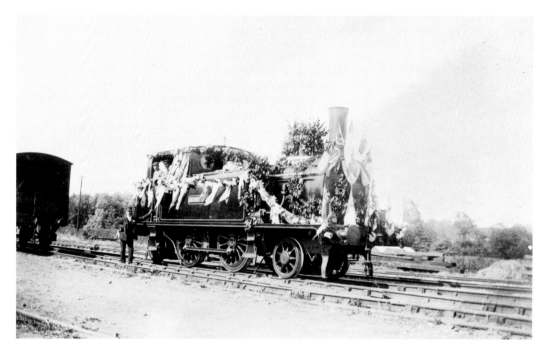

CV&HR locomotive *Hedingham* decorated with flowers for the 1908 Hedingham flower show. (CVRPS) This view cannot be recreated today as the locomotive was scrapped back in the LNER days and the yard is now a factory. Instead, the picture below shows a visiting engine to the new CVR in the form of Class J72 0-6-0 tank engine *Joem* entering Hedingham over the river bridge in July 1994. (Sally Halls)

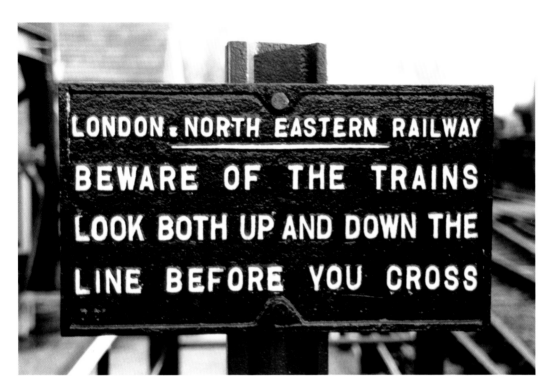

New and old: an original London & North Eastern Railway warning notice that would have been erected on a foot crossing, contrasted with a modern notice as used on the present CVR. (SH)

Halstead

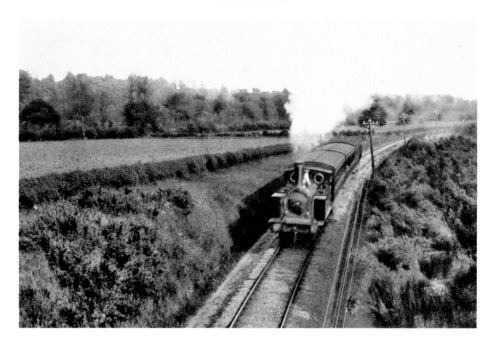

An old postcard franked for 1907 with a view of a passenger train approaching Does Corner overbridge (No. 11 on the CVR plan) between Halstead and Hedingham. (CVRPS) Looking from the site of the former road bridge (now filled in), the same view in 1994 shows the old trackbed with a new water board pumping station built on the old formation. However, all is not lost, as the route of the former railway is now a public footpath from the old bridge right back to Halstead. (RB)

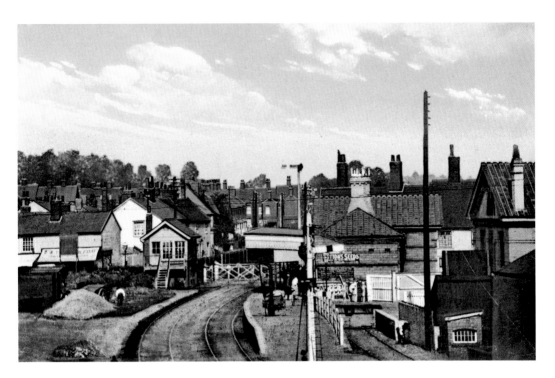

Early colour postcard view of Halstead station, level crossing and signal box with the original lower quadrant signals on wooden posts. (CVRPS) Once the track was removed in early 1966, the steel footbridge was also scrapped as there was no need for it. Today, a new road now runs through the site. (RB)

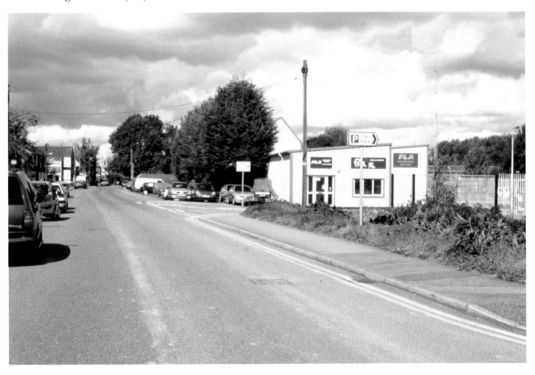

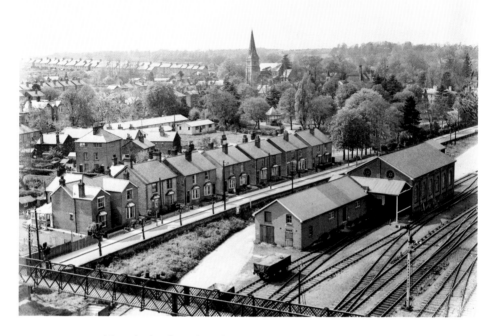

Panoramic view (above) of Halstead yard in the 1950s, taken from the nearby granary silo. The photograph shows the large goods shed and adjacent goods office, as well as Kings Road, running parallel to the railway, and Halstead church. The signal in the foreground is an LNER concrete replacement and carries the down home signal as well as the Parsonage Lane level crossing gate distant. (*Halstead Gazette*/CVRPS) In 1980 (below) the view has completely changed with all traces of the former railway having been swept away. The yard now features a large factory unit. (D. Gomer)

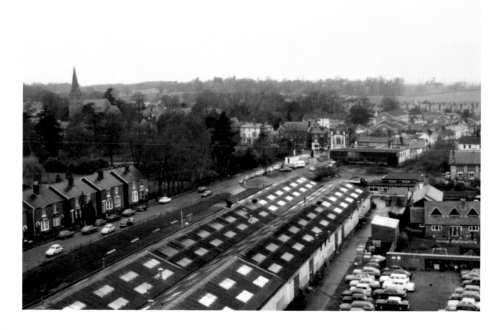

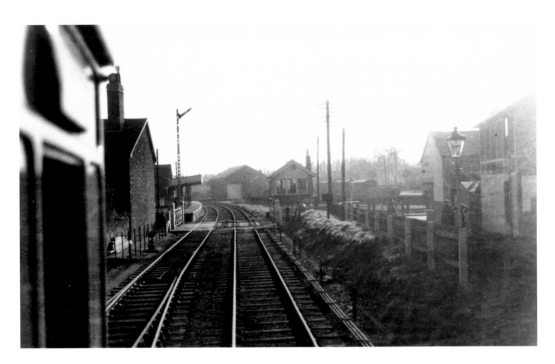

LNER view, taken on 3 November 1935, from the rear of a train and showing Halstead station, goods shed and signal box with the tall down starting signal now an upper quadrant on a concrete post. (MP92.5) The road on the left in the modern image has been widened over part of the trackbed. The houses on the left and right of the level crossing still exist, flats have been built on the site of the station, and a showroom is now on the site of the signal box. (RB)

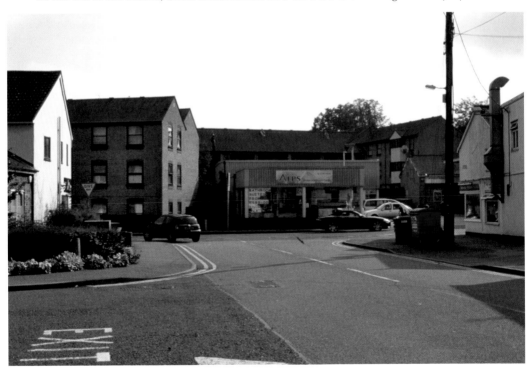

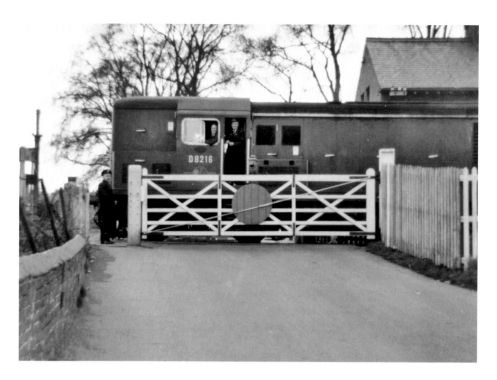

Parsonage Lane level crossing in 1965 with a Type 1 Class 15 diesel passing over the crossing to enter Halstead yard. The crossing was protected by gates controlled by a crossing keeper. During the mid-1920s the LNER closed the adjacent signal box and built a house for the new crossing keeper. Due to the limited space, the new house was very narrow but had two stories. Both buildings survived together for a number of years before the old signal box was demolished. (RH) The view today shows the road flattened out with all traces of the railway gone, although the crossing house still stands. (RB)

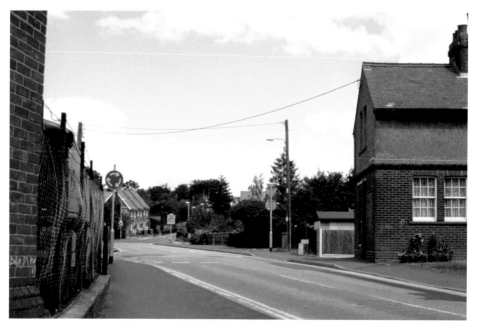

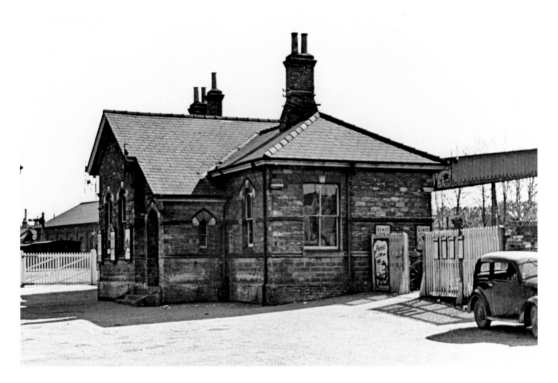

A 1947 official photograph of Halstead station and forecourt. The photographer's black car appeared in most views taken on the line at that time. (BR/CVRPS) By 1982 all that was left were the steps leading to an overgrown platform. A telephone box had also appeared. (CVRPS)

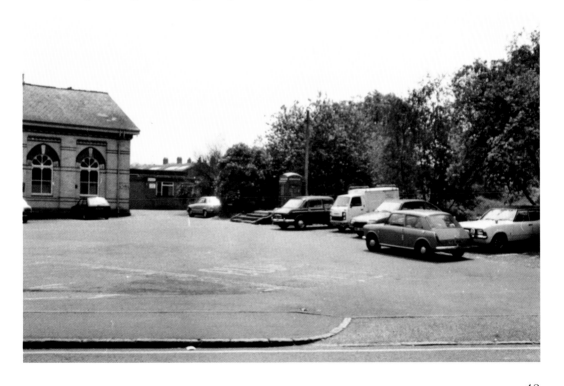

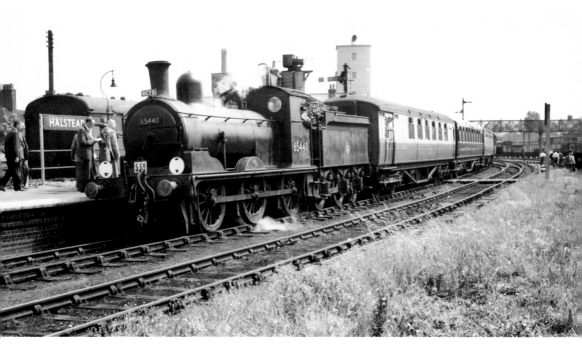

An RCTS special excursion stands at Halstead, awaiting departure in 1959. This photograph was taken from near the signal box. (J. J. Davis Collection/HMRS ACE 505) The same view today is now of a showroom and a block of flats. The station site had remained derelict for a number of years before being redeveloped. (RB)

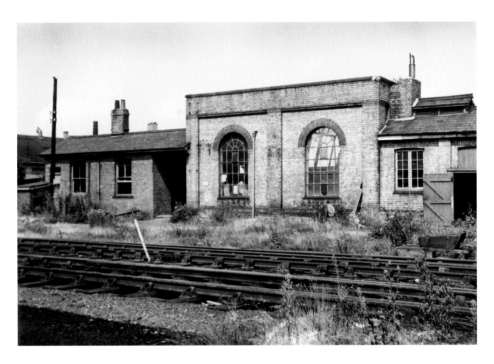

Apart from the crossing keeper's cottage in Parsonage Lane, the only other railway buildings were the former stationmaster's office, the water tower and staff mess room. By the 1960s the tank had already been removed. (MR) Nowadays, the windows have been bricked in and the right-hand chimney has been removed. The place where the photographer of the top image was standing, near the track, is now a large industrial unit. (PL)

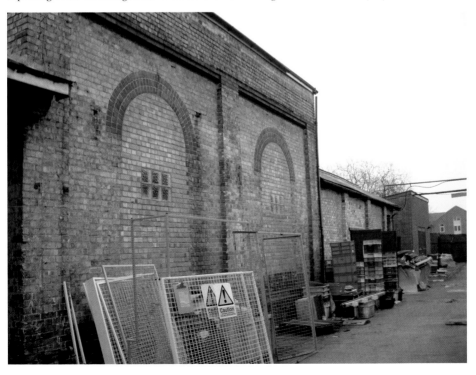

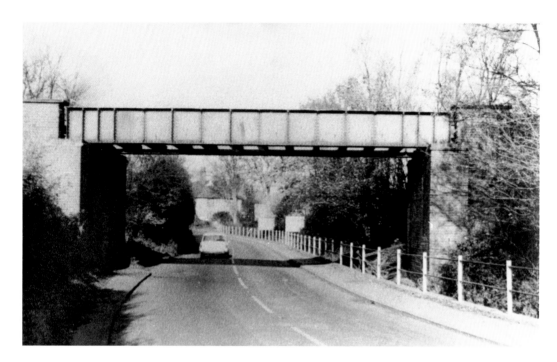

Bridge No. 8 over the former A604 (now A1124) on the approach to Halstead from Earls Colne. Like most CV&HR bridges, it had no deck between the cross-girders, as there was not very much clearance between the road and bridge. The whole structure was removed when the line was demolished in 1966. (B. A. L. Bamberger) The brick abutments have survived for over forty-five years. Although now heavily overgrown, the common feature in both views is the fence protecting the road from the adjacent ditch. (PL)

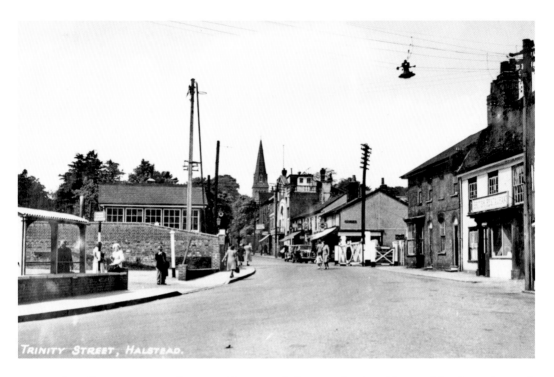

Halstead's Trinity Street from an old postcard showing the signal box and level crossing with the church in the background. (G. Barrett Collection) Today, the church remains, but the level crossing and gates were removed once the track had been recovered in 1966. Where the signal box stood is now a showroom. (RB)

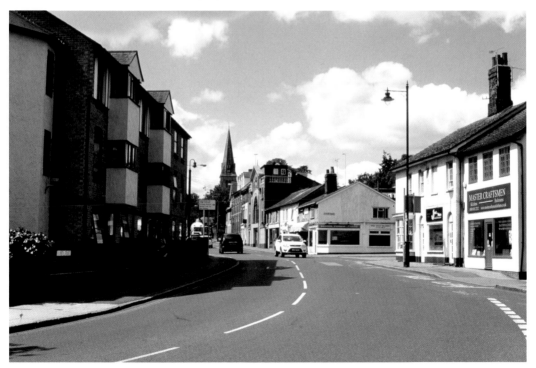

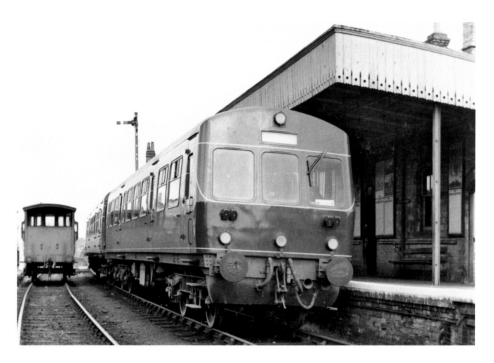

A Metropolitan-Camel Diesel Multiple Unit stands at Halstead on a trial run in June 1956. It would be another two years before the local passenger service succumbed to rail buses and DMUs. (*Halstead Gazette*/CVRPS) The same view today would be a block of flats so the photograph below is of a preserved diesel unit at the Colne Valley Railway. These diesels were introduced from the mid-1950s and a few still work on the national network. Also shown, on the right, is the 1980s replacement, the Class 141. (PL)

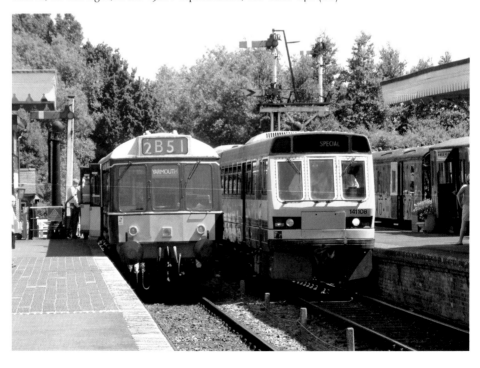

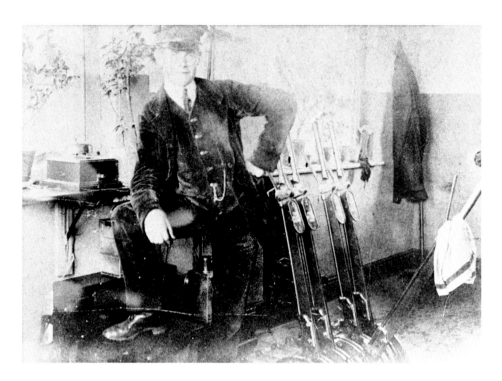

Signalman A. S. Benham in Parsonage Lane signal box in 1912 with his 5-lever Saxby & Farmer frame, which controlled just the gates and the signals protecting it. (CVRPS) The modern view is of the gate house and the fire station that now occupies part of the of the former signal box site. The signal box, having closed in the late 1920s, was not demolished until the 1950s. The crossing house still stands, but the rails have long gone. (RB)

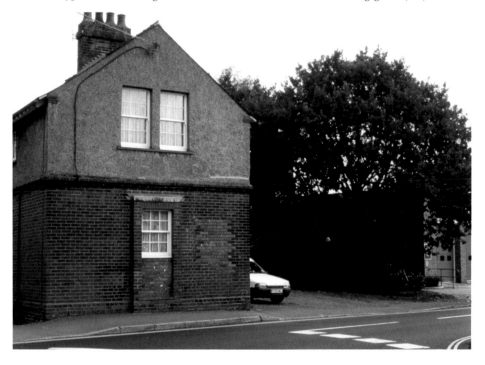

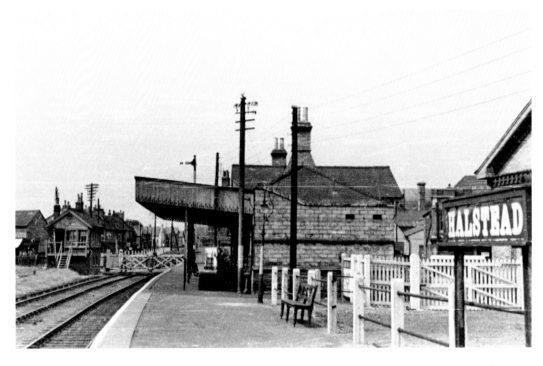

Halstead station, level crossing and signal box, looking north, as seen in the 1950s. (SUK) The more recent view dates from 1982, before the site was redeveloped into flats. Here, the former railway yard is being used as a temporary lorry park, while the gate in the centre of the frame leads to the garage that occupied the level crossing and signal box site. (CVRPS)

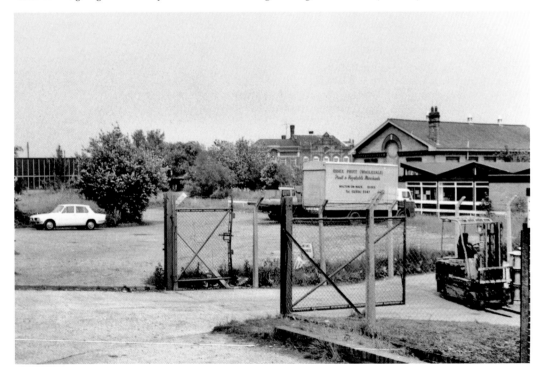

Earls Colne

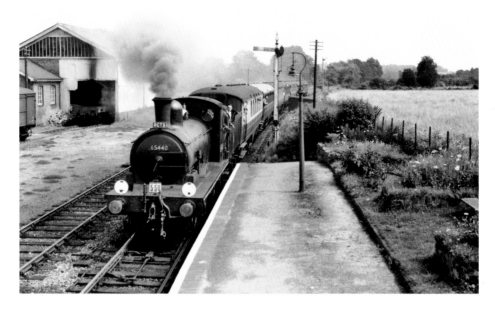

J15 locomotive 65440 arrives at Earls Colne from Chappel on an RCTS special on 10 August 1958, as seen from the signal box. (ICA/TT) The modern view is just a half-buried empty platform with the holes underneath for the signalling equipment to exit the platform-mounted signal box. The construction of new industrial units means a closer view could not be obtained. (PL)

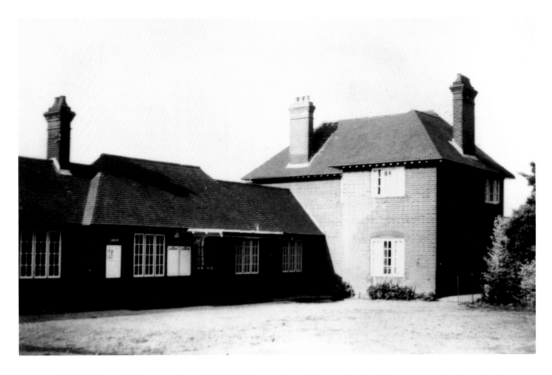

A 1947 official view of the exterior of Earls Colne station. The station had been completely rebuilt in 1903 and was renamed Earls Colne upon completion in 1905. (BR/CVRPS) Today, little has changed except the station is now a factory and the platform area has been incorporated into an extension of the original buildings. (RB)

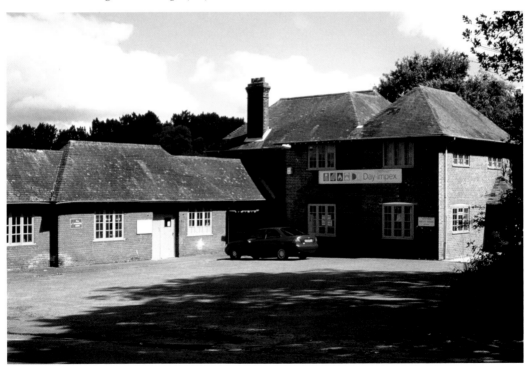

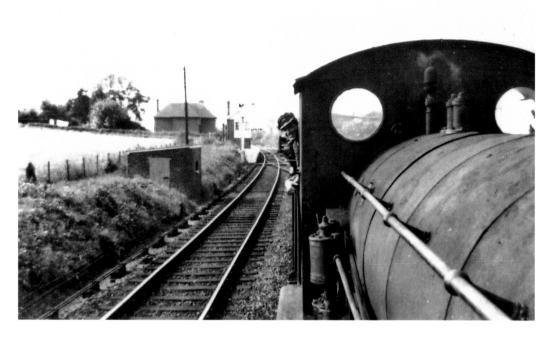

A 1950s shot of fireman Sid Chase looking back from the footplate towards the camera. The train is in the goods loop, while the passenger line, platform and station can be seen in the background. (Sid Chase Collection) As this locomotive has long since gone to the scrap yard, the modern photograph dates from 2005 and shows fireman Malcolm Hodges looking out of locomotive WD190 while it runs round its train at Nunnery Junction on the Colne Valley Railway. (ATW)

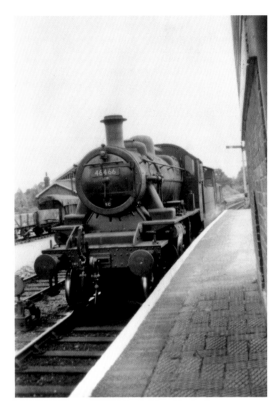

Ivatt-designed 2MT 2-6-0 locomotive 46466 arrives at Earls Colne during the mid-1950s. In the background can be seen the goods yard with plenty of wagons waiting for dispatch. Today, there is a small portion of the platform left undeveloped. Unfortunately, it is not accessible to be photographed due to the building of a new industrial unit, upon the completion of which the platform will be gone forever. (VS) As it was not possible to recreate the old photograph, an alternative image from the 1990s is provided. The Class J72 0-6-0 tank engine *Joem* is shown arriving at Castle Hedingham station with a down passenger service. The signalman waits to exchange the token with the driver. *Joem* was on a short visit to the Colne Valley Railway at Castle Hedingham. (ATW)

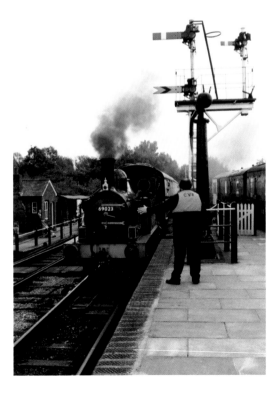

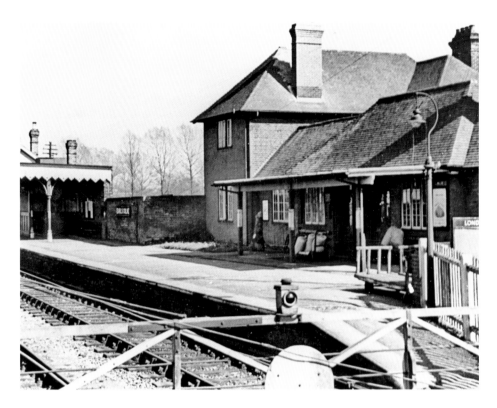

A view from the far side of the level crossing, looking toward the station, platform and buildings. This photograph is dated 1947, the year when the line was surveyed prior to nationalisation in 1948. (BR/CVRPS) Today, the station building remains, but a concrete extension has taken over the platform and trackbed. (RB)

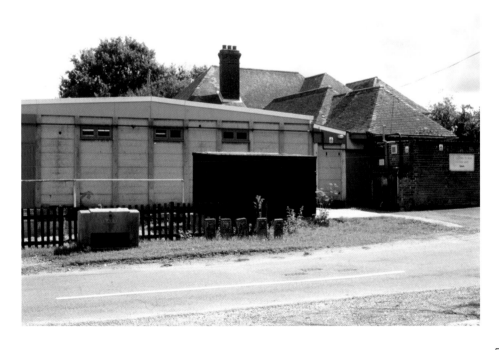

Two posed pictures taken by the local signalman Mr Sayer in the mid-1950s. The first features his daughter and the stationmaster's daughter posing with the train crew at the end of Earls Colne platform, with a Class 2MT locomotive as a backdrop. Later the same day, the locomotive crew and their dog pose for the camera. Unfortunately, the identity of the crew is not known. The taking of such pictures would not be possible today with our health and safety rules. (VS)

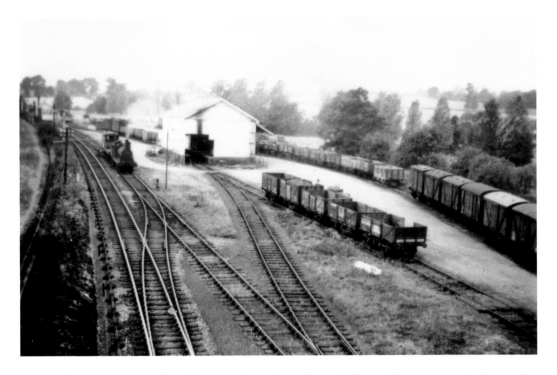

A fine wartime view of Earls Colne station and goods yard, full up with wagons as a J15 locomotive shunts in the yard. The photograph was taken in the 1940s from the top of the down home signal. (VS/CVRPS) Today, there is no down home signal to climb. The photograph below was therefore taken at ground level and shows the goods yard now redeveloped as an industrial estate. (PL)

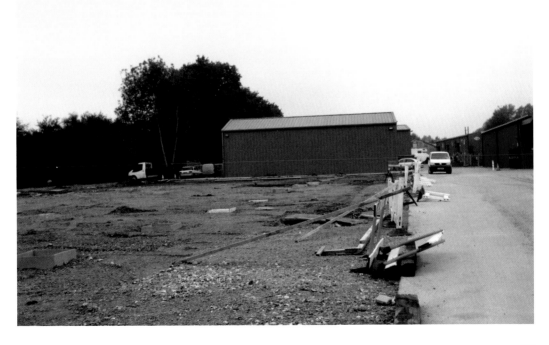

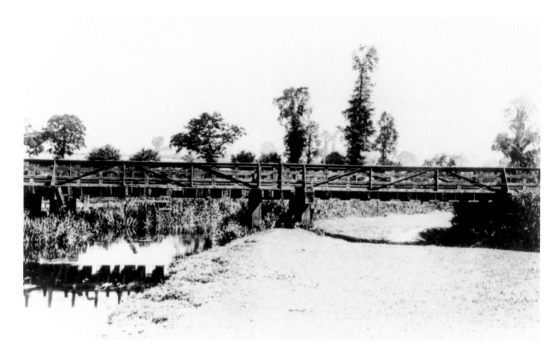

Bridge No. 5, an original CV&HR structure that had to be replaced in 1907 due to the heavier locomotives using the line by that time. This structure – a mixture of cast- and wrought-iron girders with timber baulks – served the line well for forty-seven years. (R. F. Hilton/HMRS ABC 431) The modern image is of CV&HR underbridge No. 6. Relocated from Earls Colne to the new CVR, it is once again carrying trains over the River Colne. The original LNER No. 19 bridge plaque was affixed to the abutment wall. This was the number of the original bridge at this location. (ATW)

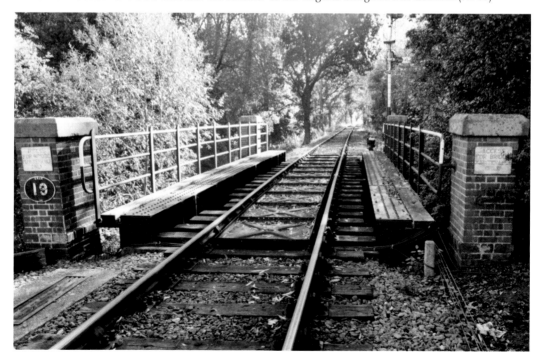

White Colne

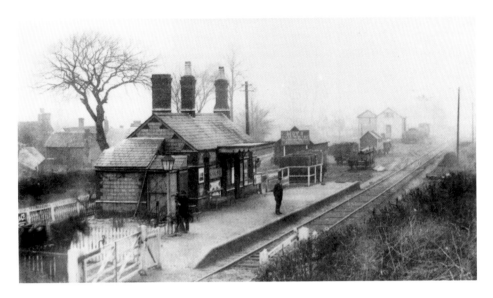

The original Colne (later White Colne) station, as seen in 1889 with the platform on the Halstead side of the crossing gates. The design of the building in this original form looks very similar to that at Hedingham. In 1889, the Colne Valley Board decided to close Colne station to all traffic; they transferred the name to the nearby Ford Gate station. In 1907, the old Colne station reopened to goods traffic and regained its passenger status and a new platform when, the following year, the station was renamed White Colne. (MB) The view today shows the station building intact and used as the local village hall, minus a couple of chimneys. (PL)

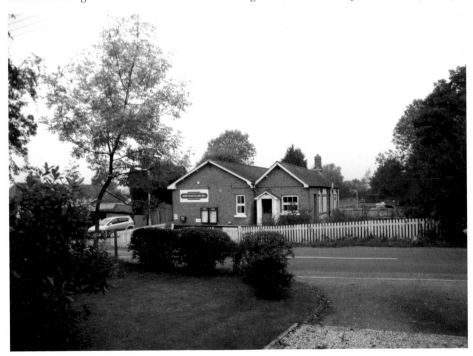

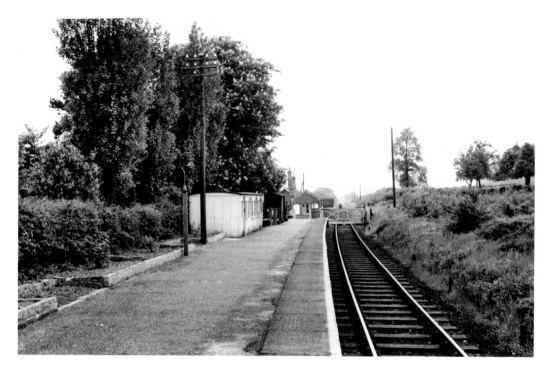

A view of White Colne station, taken from the platform with the level crossing and station buildings in the distance. (SUK) By the early 1980s, the rails were long gone and nature was taking over the platform and trackbed. Three houses have now been built on the former railway and surrounding land. (ATW)

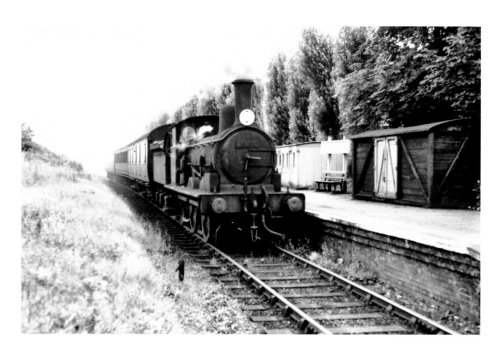

A J15 locomotive on a local passenger service running into White Colne station. Note the use of an old van body as a lock-up and a passenger coach as a waiting room. (ICA/TT) Today, this view has now completely disappeared under a housing development. However, when the platform was being demolished, the large coping stones were bought by the new Colne Valley Railway for reuse on the new station's bay platform. The view below, looking towards Chappel, shows the development of private housing, but the trees along the boundary still exist. (PL)

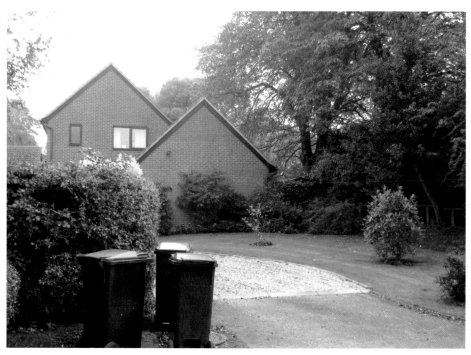

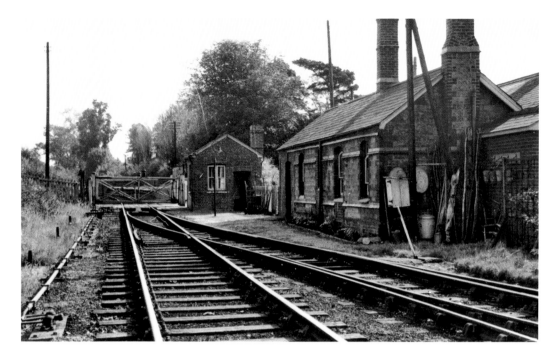

A view looking towards Chappel, showing the original station building with its new extension on the back, built in LNER times for the crossing keeper. The brick building adjacent to the level crossing housed the level crossing 4-lever ground frame, while the points to the siding were controlled by a separate ground frame seen on the left of the picture. (SUK) The view today shows the station in use as the village hall with the former goods yard turned into a car park and playground. (RB)

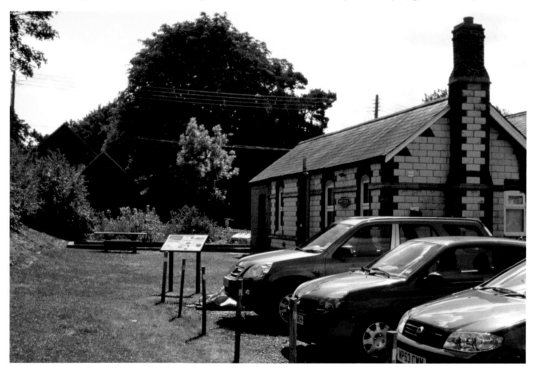

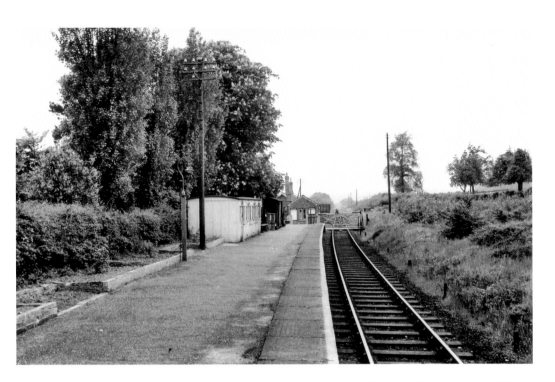

White Colne station in happier times with the platform neat and tidy and the gardens well kept, as seen looking towards the level crossing and station building in 1952. (SUK) A few years later, White Colne is reflected in greater detail as the photographer leans out of a train window to take a snap of the station as it was in May 1956. (R. C. Casserley)

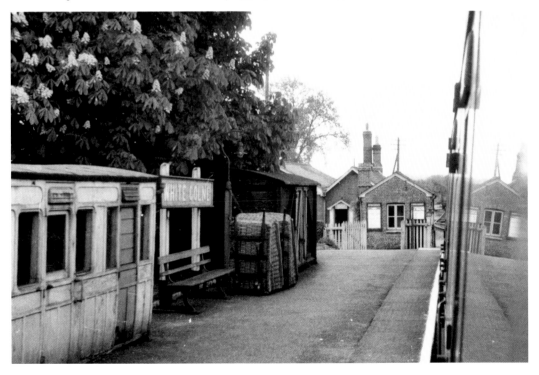

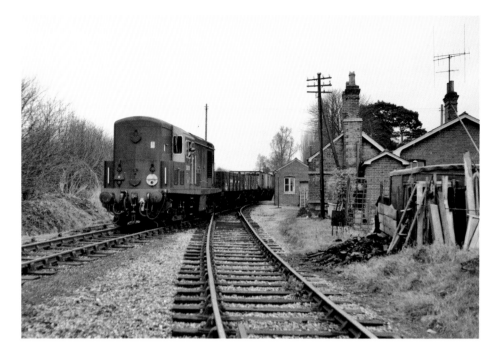

Class 15 Type 1 diesel D8228 passes White Colne goods yard with a local freight train in the 1960s. The track in the foreground led into the yard. Note the pile of coal, for the local crossing keeper, dumped in a pile by the side of the fence. (ICA/C15PS) The modern view is from the car park looking towards the buildings. The former trackbed is now a grassed area with seats looking towards the new housing development. (PL)

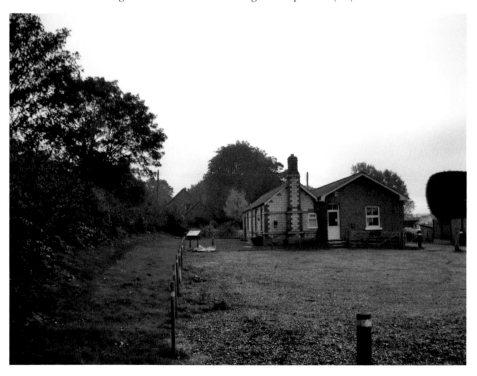

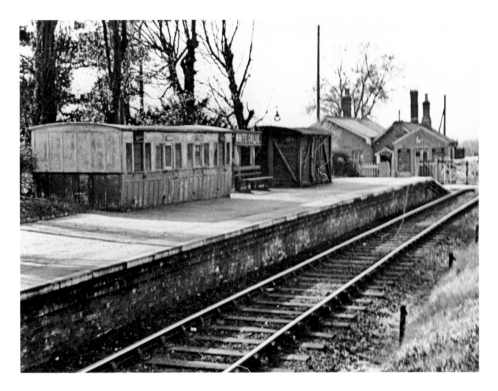

Another view, from 1947, of White Colne station, platform buildings and level crossing. The photograph was taken from the up side embankment looking towards Halstead. (BR/CVRPS) By the 1980s, the station platform was empty except for weeds and shrub growth, the station buildings had been converted into the village hall, and the former crossing keeper's hut had already been relocated. The view today, taken with permission from a private garden, is an attempt to recreate the image above. (PL)

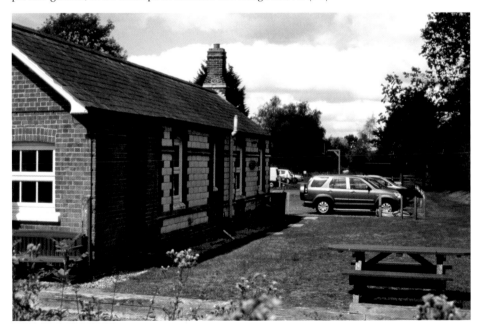

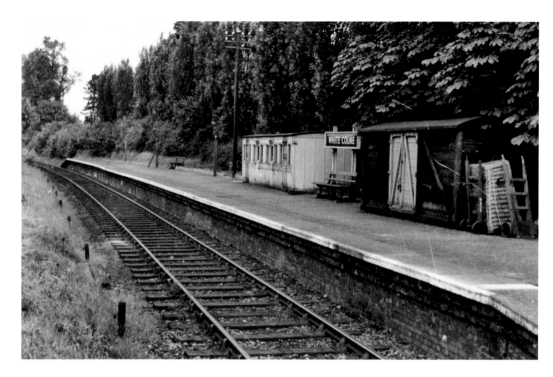

The empty platform (above) at White Colne, with its lock-up and old carriage body, awaiting the next train in the early 1960s. By this time there were only four diesel passenger services each way serving the station. (RH) The view below dates from the 1980s and shows the overgrown platform. Today, a small housing development stands on the site. The platform's coping stones were reused at the Colne Valley Railway at Castle Hedingham. (ATW)

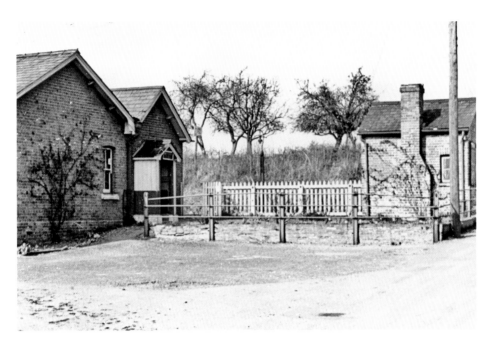

A 1947 view of White Colne station building and the crossing keeper's hut with a small bit of fenced-off garden between the two. Prospective passengers purchased tickets from the alcove that housed a serving hatch, then crossed the road to the platform. The crossing keeper's hut was built in 1907 to house a 9-lever signal frame for working the signals and points to the goods yard. This building has since been donated to the new Colne Valley Railway and was taken down brick by brick and rebuilt at its new home. (BR/CVRPS) The view in 2010 shows the former station buildings converted into the local village hall, while the former yard is now a car park and children's play area. (PL)

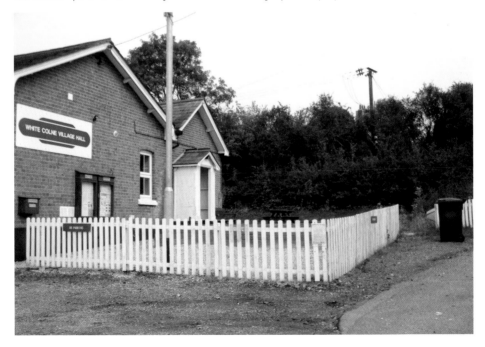

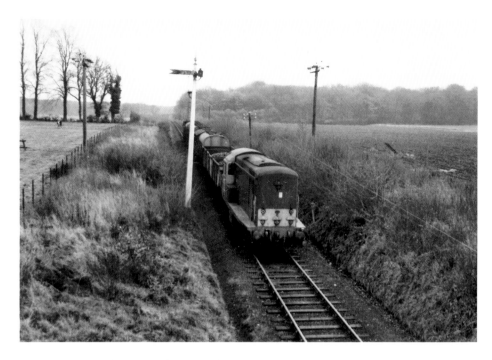

A Class 15 Type 1 diesel on a local freight working, viewed from CV&HR overbridge No. 2 with the Chappel up fixed distant signal to the left. All the local goods services were handled by these diesels due to the severe weight restrictions over the Colne Valley line. (Dr I. C. Allen/Class 15 Preservation Society) In the present-day view, the bridge has since been demolished and the trackbed ploughed in at this location. However, the woods are still there, as is overbridge No. 1. (PL)

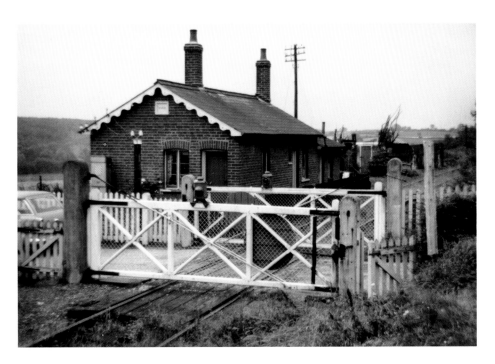

The first level crossing on the Colne Valley line was located at Boley's Road and was known as 'Fox and Pheasant', named by all the locals after the nearby farm. A crossing keeper's bungalow was provided and the crossing itself was protected by distant signals worked from an adjacent ground frame and with red lamps on the actual gates. (RH) By 1980, the railway had been gone for a number of years and the crossing keeper's cottage had been extended onto the former trackbed. The whole area has since been redeveloped into a large private dwelling with all signs of the railway obliterated, apart from two wicket gates seen in the earlier picture. (PL)

Chappel Junction and Chappel & Wakes Colne

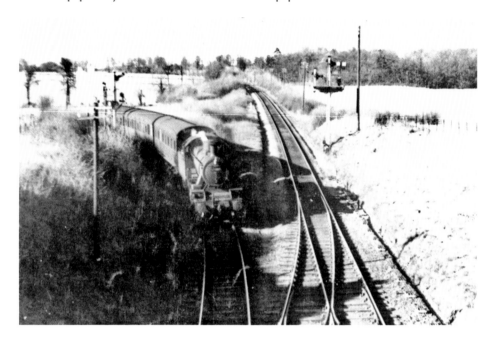

An Ivatt-designed Class 2MT 2-6-0 locomotive and a Haverhill to Marks Tey passenger train joining the Stour Valley line at Chappel Junction in the late 1950s. (P. Waylett/CVRPS) The view today shows the surviving Stour Valley line (Sudbury branch) having been slewed over to the centre of the formation. The site of the junction is completely lost among the trees and shrubs. Some old track panels have been stacked on the left, where the junction was located. Beyond the boundary fence, the trackbed of the Colne Valley line has been absorbed into an orchard. (RB)

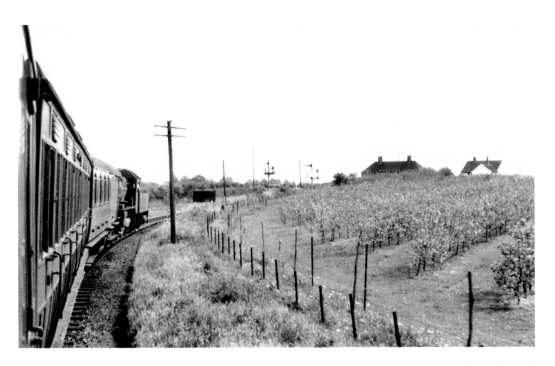

An Ivatt-designed 2MT No. 46468 on a Colne Valley local service train, approaching Chappel Junction on 26 May 1956. Note the fine examples of semaphore signals protecting the junction; the train has been signalled into the down platform at Chappel. (H. C. Casserley) The present-day view shows the railway formation completely gone and the orchard, seen in the earlier picture, extended over the former railway ground. (RB)

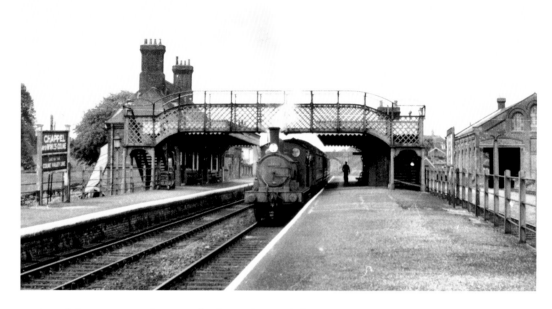

A view of the 13.33 train from Cambridge and Haverhill arriving at the up platform at Chappel station on 26 May 1956, hauled by Class J15 locomotive 65448. In the distance can be seen the overbridge where the junction between the two lines was located. When the passing loop was done away with by British Rail in 1967, the footbridge was demolished and the signal box closed. (HCC) The photograph below, taken in the 1980s, shows the main line now singled but with the East Anglian Railway Museum thriving in the former goods yard. (ATW)

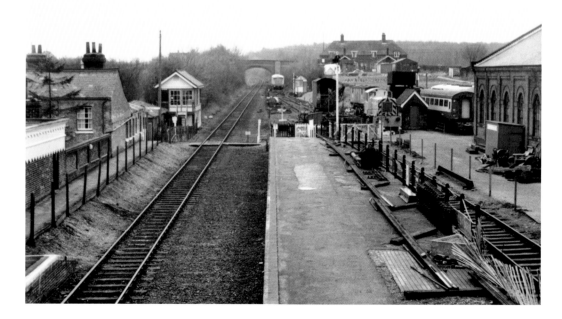

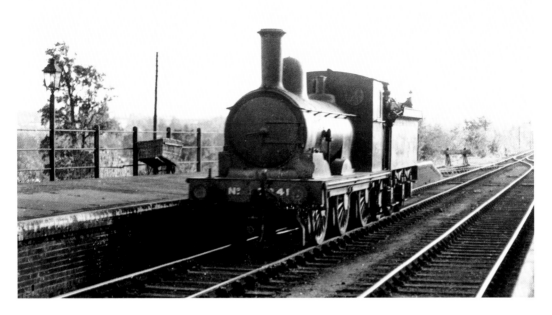

A J15 locomotive 7941 during the LNER period, seen at Chappel & Wakes Colne up platform, running light engine and awaiting the signal on 19 October 1935. (HCC) The present-day view shows the former up platform, which is now part of the East Anglian Railway Museum, the Network Rail infrastructure being limited to the track on the right. (RB)

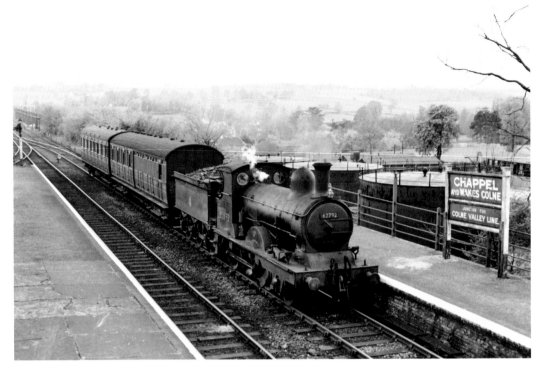

A J15 locomotive 62792 and a passenger train arriving at the down platform at Chappel & Wakes Colne in the 1950s. Note the splendid running-in board displaying 'Junction for Colne Valley Line'. The tanks in the background were for a wartime fuel storage depot that supplied local airfields. (ICA/TT) The modern image shows a Class 153 Sprinter unit calling at the station on a Saturday during the autumn of 2010 with a Sudbury-bound service. (RB)

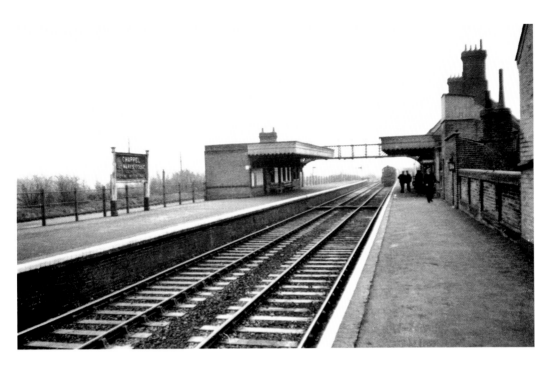

From approximately 1944, some Colne Valley passenger trains started to and from Marks Tey as separate trains. However, the practice of the joining and splitting of services still took place at Chappel well into the 1950s. The image above dates from 1953 and looks towards Marks Tey as a down train arrives. (SUK) Today, more than fifty years later, the down platform has been shortened and the buildings on Platform 2 have long since been demolished. The photograph below looks north as a Class 153 Sprinter unit passes the former Chappel & Wakes Colne signal box, now part of a museum. (RB)

Marks Tey

The photograph above is a 1961 view of Marks Tey station, looking in a westerly direction as a Brush Type 2 (later designated Class 31) arrives at the down main platform. A connecting DMU waits in the branch platform. The fine semaphore gantry was soon to be swept away when the station was resignalled prior to electrification. (SUK) The modern photograph below was taken some forty years later. The electric era was well advanced and the station had been resignalled again in 1997. The branch platform had been reduced to a two-coach platform, while the goods yard is now a car park. (RB)

Colne Valley Railway at Castle Hedingham

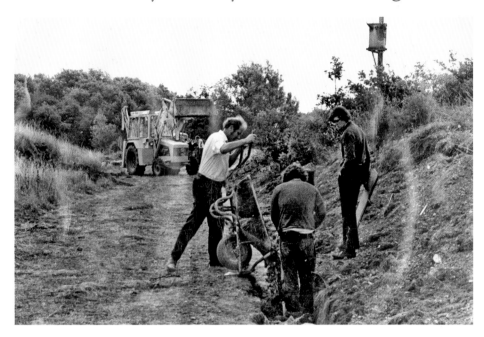

Work starts on the new Colne Valley Railway (above) with the construction of the platform wall for the second station building. The overhead power pole just visible on the right of this scene was later diverted underground. When compared to more recent views of the finished railway, the size of the task that was undertaken to rebuild a railway from scratch can be better appreciated. (CVRPS) By September 1977 (below) much had been achieved as both platforms had been constructed and some track laid. The base of the signal box is on the left by the water crane, while the power pole is a common feature in both photographs. (ATW)

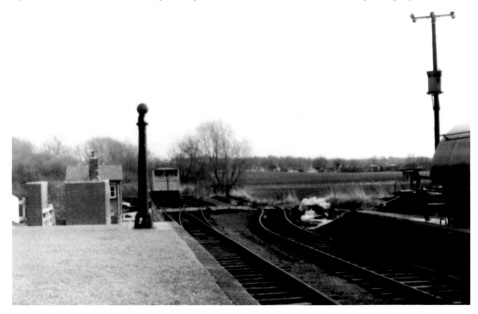

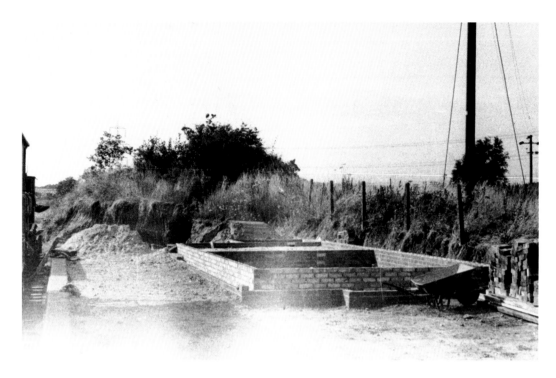

The photograph above documents the laying of foundations for the rebuilding of Sible & Castle Hedingham station in early 1974. The wire fence behind the building was the original railway boundary fence; the land behind has since been purchased to allow the station building to be extended. (ATW) The same view (below) some twenty years later, in 1994, shows locomotives No. 40 and WD190 hauling a train into the station platform. (ATW)

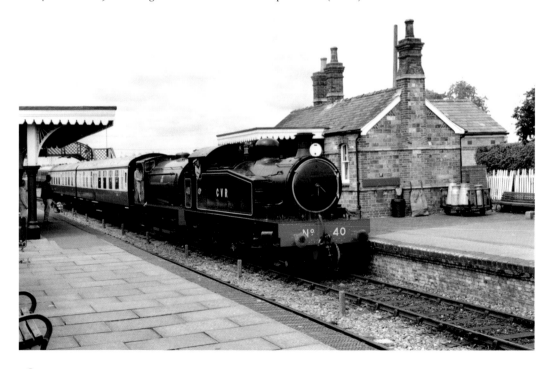

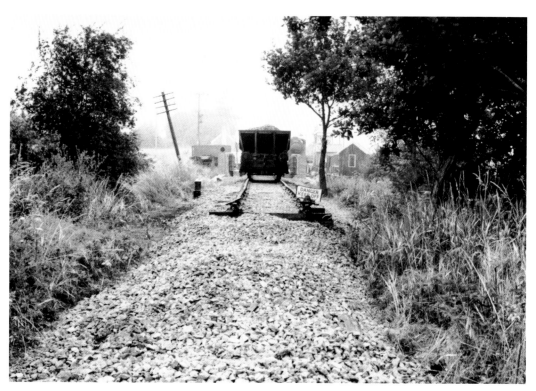

The photograph above shows the first
track to be relaid over the river, in 1981,
on the new Colne Valley Railway. Several
feet of formation had to be rebuilt here
and the embankment adjacent to the river
had to be rebuilt after an old tree had
blown down and taken the surrounding
ground with it. By 1987, the track over
the river had been completely relaid and
ballasted to a high standard; the picture to
the right looks back towards the station.
(ATW)

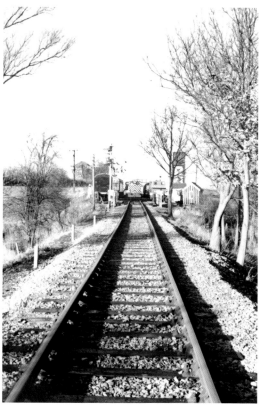

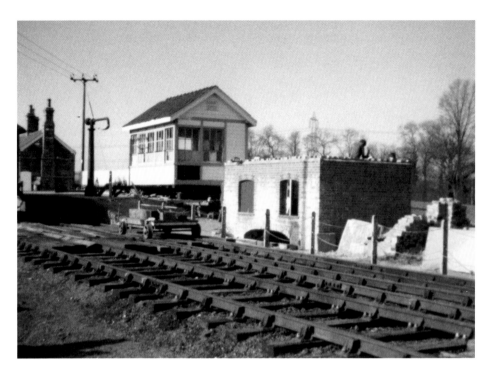

The former Cressing signal box had arrived on site in 1977 after it had been decommissioned by British Rail. It spent the next three years being repaired and moved down the line to sit on the platform edge, waiting for the final move onto its new brick base. A photograph from March 1980 shows the box shell being lifted off the platform and edged slowly towards its new home. (Vince & Sally Halls)

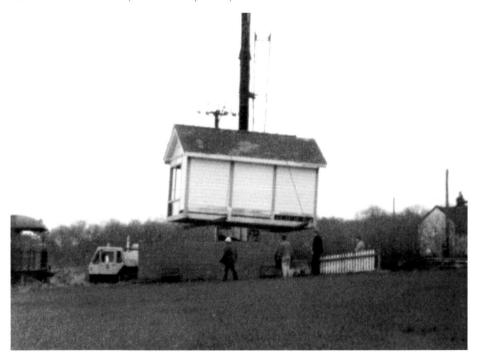

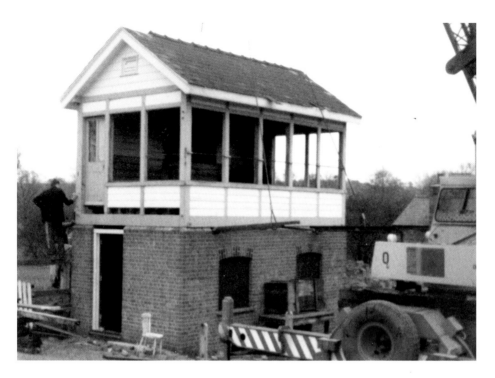

The signal box shell arrives at its new home, minutes after the previous photograph was taken. The following day, the box shell was tied down with steel plates onto the brick base and the windows were all replaced. (V&SH) The interior view of the former Cressing signal box shows it fully restored and operational during the 1990s. When used at its previous home, it had a maximum of fifteen working levers, later reduced to five working levers in the 1960s. At its new home, it started life with fourteen working levers, later expanded to eighteen in 1993 and finally to twenty in 2008. (ATW)

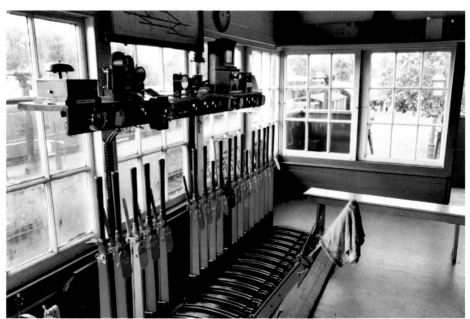

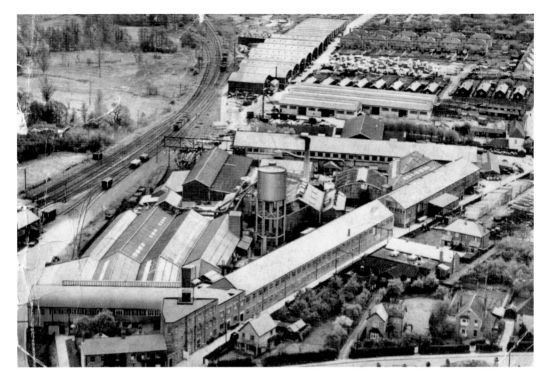

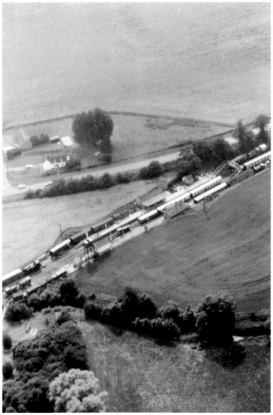

Two aerial shots of the Colne Valley line. The first dates from the 1950s and shows the Sible & Castle Hedingham station and goods yard along with the nearby timber works, a good customer of the line. (ACB) The later image of the Colne Valley Railway was taken from the air during a fly-past in the 1990s by one of the railway's members. (Brian Smith)

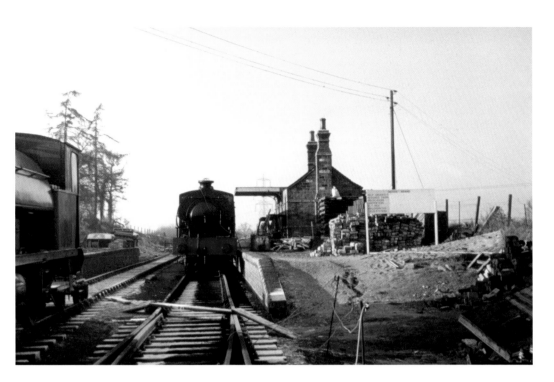

Early days at the new Colne Valley Railway. The image above shows the platform and station building nearing completion in 1976. The signal box was yet to be built. Over a decade later, the bottom image shows a very busy scene at Castle Hedingham station with locomotives and other rolling stock in view. By this time, the water tower and signal box had been built and newly salvaged signals had been installed to control the new layout. (ATW)

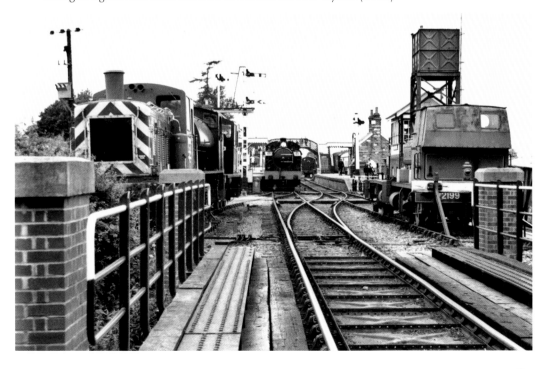

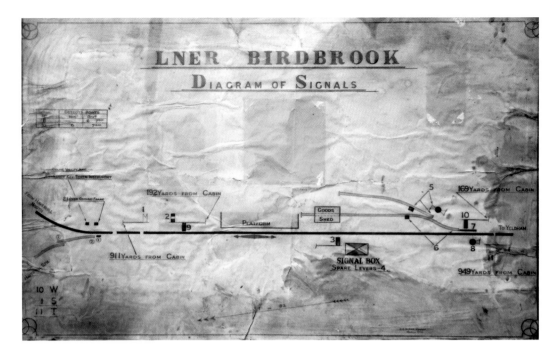

Signal box diagrams old and new. The diagram above, from Birdbrook signal box, was saved when the box closed on 30 December 1961. Dated 1930, it was sold to Vincent Heckford and passed to CVRPS when he died. (PL) As a comparison, the diagram below for Nunnery Junction on the new Colne Valley Railway is reproduced. This diagram is dated 2005 and has since been redrawn to take into account infrastructural changes in that area. (ATW)

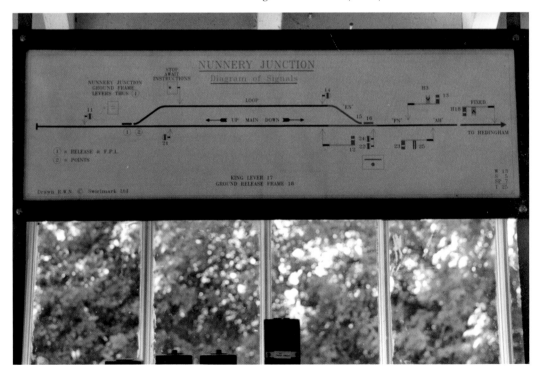

A 1980 photograph (right) of the
trackbed looking south towards
Castle Hedingham village, awaiting
restoration of the rails that were
ripped up in 1965. It was to be
another five years before the
track was laid to the limit of the
available land. By the late 1980s
(below) the scene was completely
changed with the former Wrabness
signal box now in control of this
part of the line. (ATW)

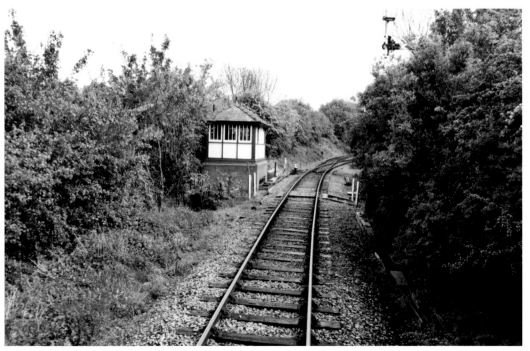

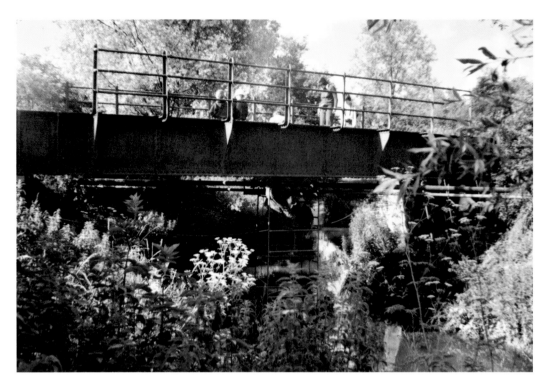

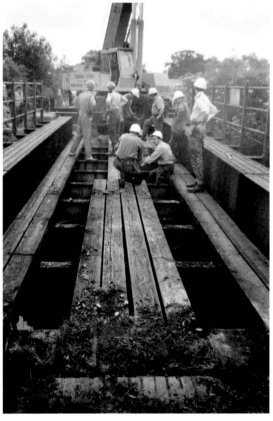

The biggest engineering task to be undertaken on the new Colne Valley Railway was the replacement of the missing river bridge at Castle Hedingham, which had been removed for scrap when the line was dismantled. There was one remaining bridge near Earls Colne which was in use by the water board for access to a pumping station. It also supported a sewage pipe. Permission was given to remove the rail bridge and replace it with a footbridge; the railway members were assisted by the Royal Engineers in this task. The image above shows the bridge being prepared for the lift at Earls Colne; the sewage pipe was temporarily supported on a scaffolding tower built into the river. The image to the left is of the top view of the bridge with the crane being prepared for the main lift. (ATW)

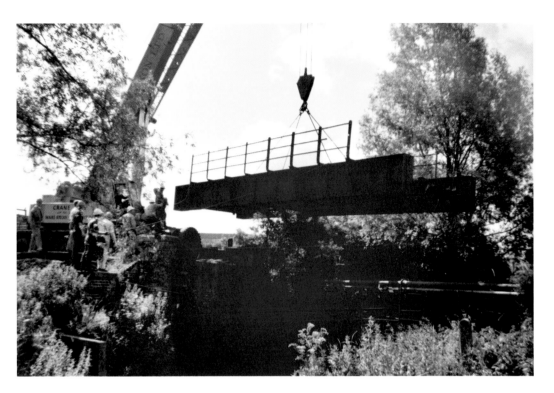

The top photograph, dated 5 July 1980, shows the bridge being lifted from its home at Earls Colne, where it was installed way back in 1909. The replacement footbridge (below) was craned into the gap left by the former railway bridge on the same day. (ATW)

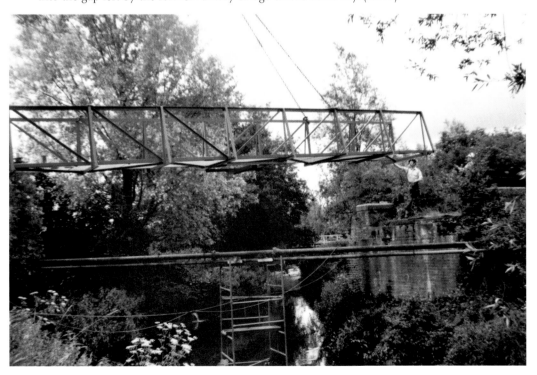

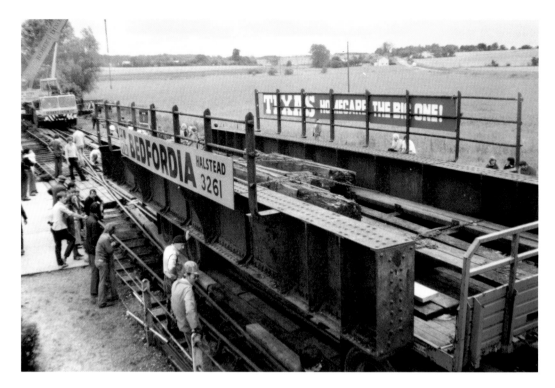

The bridge was transported by road to Castle Hedingham where, after being carefully backed down to its new home, it was craned into position. Before the track could be relaid the bridge had to be shot-blasted and painted. Also, the cross-girders needed new plates to be welded onto them to repair some wasting of the steel, and new weigh beams had to be installed. Finally, the abutments had to be repaired before track-laying commenced. (ATW)

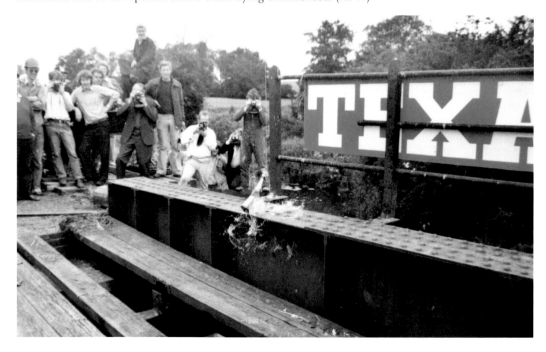

Once the bridge over the River Colne had been replaced, a further half-mile of trackbed became available for the re-laying of the ballast, sleepers and rails. It was to take nearly five years to raise the funds and lay the track. The new extension was fully commissioned at Christmas 1985. (V&SH) Below, 0-4-0ST *Victory* can be seen crossing over the bridge into Hedingham station on gala day in 1988. (Steve Wright)

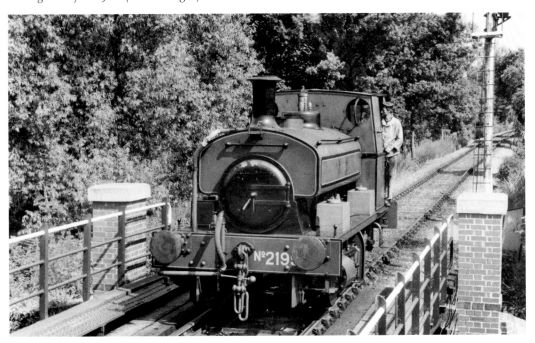

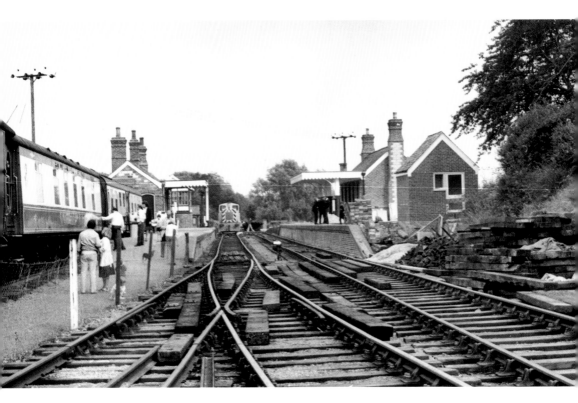

By 1982 a lot had been achieved; however, as can be seen above, plenty still needed to be improved on the new railway. Some twenty-four years later, the railway has gained a water tower and new bracket signal (ex-Spalding), while the power lines have been diverted underground. (ATW)

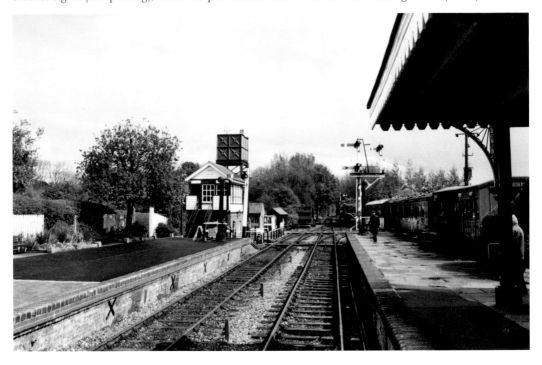

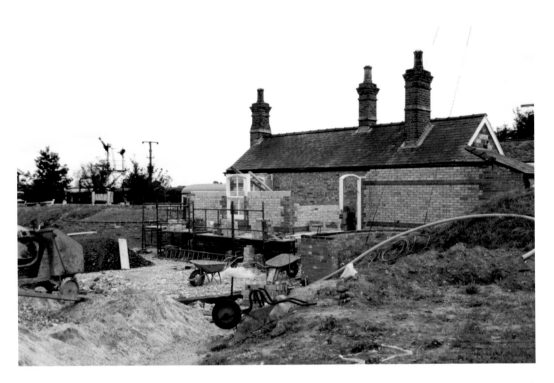

The railway purchased an extra 14 acres of land in the 1990s in order to build a new access road, car park, extra sidings and engine sheds. Hedingham station building was extended to provide extra office space. The above photograph was taken in the mid-1990s as work was progressing on the extension – the brickwork matched the existing design. (SH) Today, the whole area has been levelled and fenced, which forms a tidy entrance to the station. (RB)

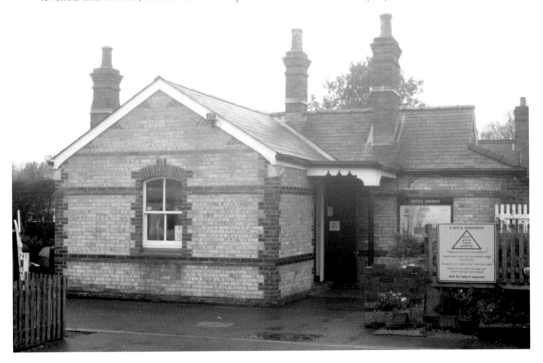

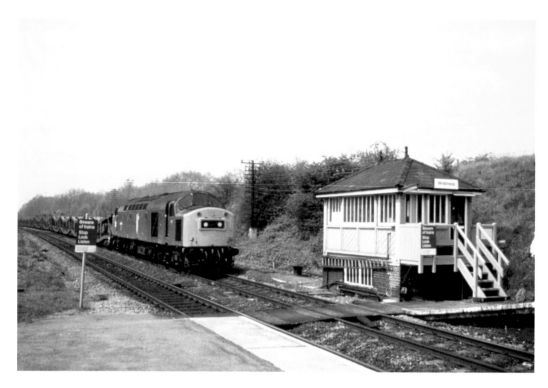

Wrabness signal box and a passing freight train in British Rail days, May 1983, a few months before it was taken out of use. (N. L. Cadge) The lever frame was dismantled and all other services disconnected. The signal box top was lifted off its base during a night-time operation and craned over the overhead wires onto a lorry for transportation to Hedingham. (RB)

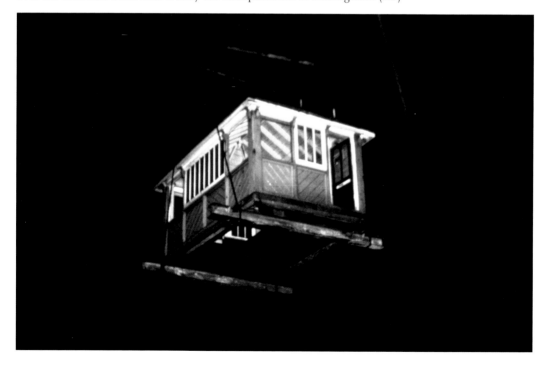

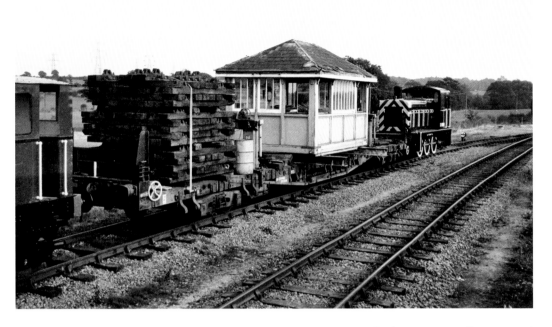

Out-of-gauge load and engineering train, in 1986, waiting in the loop at Drawell to proceed towards the other end of the line to offload the former Wrabness signal box onto its new base. (CVRPS) The more recent photograph below is of Nunnery Junction, the box's new home, where it is once more signalling trains. (RB)

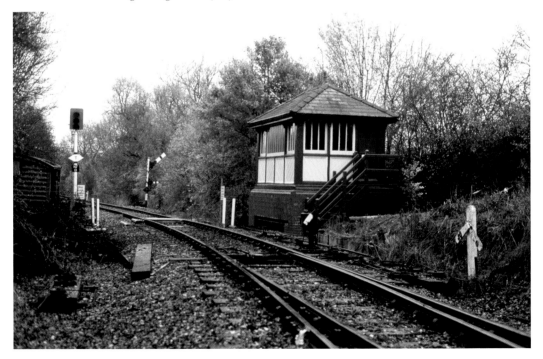

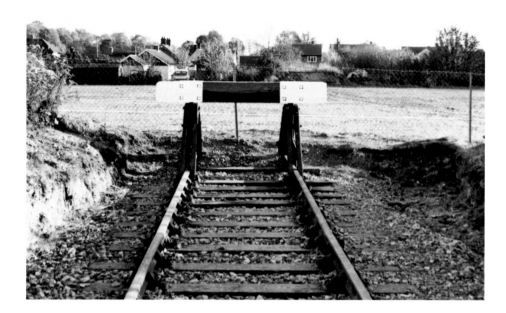

End of the line in 1986. The local landowner had the abandoned trackbed flattened to incorporate it into the adjacent fields, while a portion of the former trackbed can be seen in the distance in front of the new houses. (ATW) The same view in 2010 reveals the field to be a building site once more, as the CVR has purchased the land and is extending the line towards the village again. (RB)

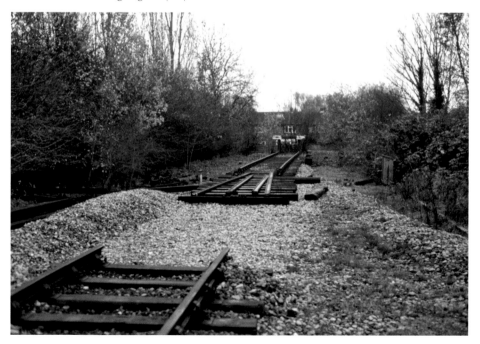

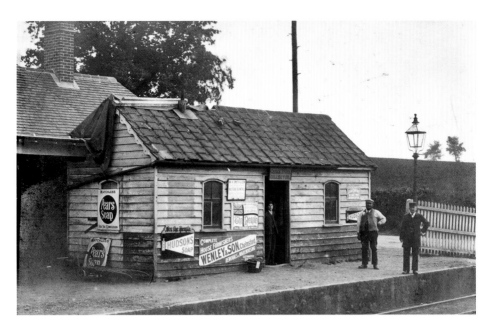

The picture above, dating from around 1903, is of the original Ford Gate station building, before it was removed and sold to a local builder for reuse as an office. The newer station building can be seen on the left of the photograph. In 1905, the station was renamed Earls Colne to avoid confusion with Colne in Lancashire and Calne in Wiltshire. The gentleman standing on the edge of the platform was George Evans, who was born in 1856 and started working on the railway as a clerk and was later promoted to stationmaster at Colne (White Colne). When that station closed in 1889, he transferred to Ford Gate, renamed Colne in 1889 and Earls Colne in 1905, and remained stationmaster there until he retired in 1926 at the age of seventy. (CVRPS) The colour photograph depicts one of the heaviest locomotives to work on any part of the Colne Valley line – diesel locomotive 31255 – which is seen in EWS livery running round its train at Nunnery Junction in July 2007 on the preserved Colne Valley Railway. (ATW)

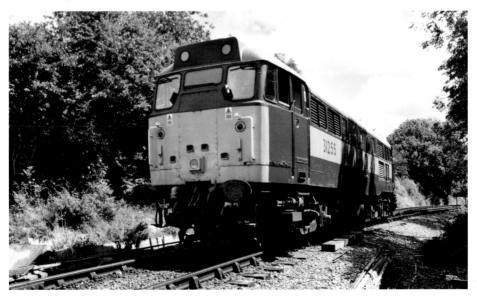

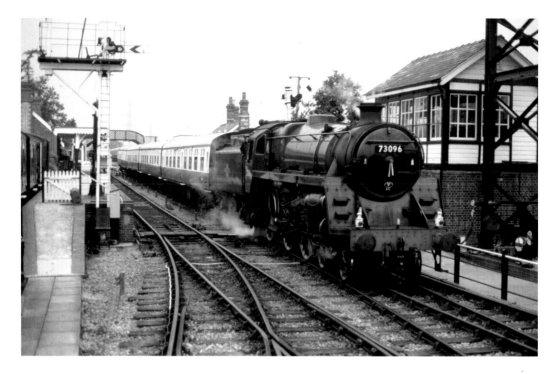

A BR Standard Class 5 locomotive on a visit to the Colne Valley Railway in 1997. Apart from the Class 31 diesel, this is one of the heaviest locomotives to run on the rebuilt railway – something that could not have taken place in the British Rail era as the axle loading on the line prohibited it.

Acknowledgements

Special thanks to Ray Bishop (RB) for the colour slides, and to Paul Lemon (PL), Adrian Corder-Birch (ACB) and Malcolm Root (MR) for help with the archive material. Also, thank you to all the other photographers and collections that are credited in the text and those abbreviated as follows: CVRPS Ltd Collection (CVRPS), Historical Model Railways Society/ H. F. Hilton Collection (HMRS/HFH), Mile Post 92.5 Picture Library (MP92.5), Dr I. C. Allen/ Class 15 Preservation Society (ICA/C15PS), Dr I. C. Allen/Transport Treasury (ICA/TT), R. M. Casserley (RMC), Ron Hutley (RH), Stations UK (SUK), Sally Halls (SH), Vince & Sally Halls (V&SH), Vic Sayer (VS), M. Brooks Collection (MB) and H. C. Casserley (HCC).